STORIES IN SAND
THE ARABIAN NIGHTS

DAMON LANGLOIS

Copyright © 2024 Damon Langlois

All rights reserved.

This book is protected under the copyright laws of Canada and other countries. No part of this publication may be reproduced, stored in a retrieval system, or transmitted in any form or by any means, electronic, mechanical, photocopying, recording, or otherwise, without the publisher's prior written permission, except for brief quotations in critical reviews or articles.
For permissions requests, please contact:
Damon Langlois
damonlanglois.com

The stories, names, characters, and incidents portrayed in the 1001 Nights stories are fictitious. No identification with actual persons (living or deceased), places, buildings, and products is intended or should be inferred.

The memoir stories reflects the author's present recollections of experiences over time. Some names and characteristics have been changed, some events have been compressed, and some dialogue has been recreated.

Book cover by Damon Langlois
Illustrations by Damon Langlois
Photographs by Damon Langlois

Firtd Edition 350 copies

ISBN: 978-1-7390146-2-9

Printed in China

www.storiesinsand.com

Dedicated to my sand sculpting mentor, friend, and big boss of this job, Ted Siebert.

This book is also dedicated to the artists. I am infinitely grateful to know and work with you all. Your artistry and integrity shine throughout this book. They are:

Adam Dunmore, Agnese Rudzite Kirillova, Aleksandr Skarednov, Alexsey Samolov, Anatolijs Kirillovs, Andrey Vazhynskyy, Andrius Petkus, Anika Koenigsdorff, Arianne van Rosmalen, Barry Swires, Benjamin Probanza, Bob ATISSO, Bouke Atema, Brent Terry, Brian Turnbough, Bruce Phillips, Calixto Molina, Charlotte Kolff, Damon Langlois, Daniel Doyle, Dave Wielders, Delayne Corbett, Denis Bespalov, Denis Kleine, Dennis Storlie, Dmitry Klimenko, Egor Ustyuzhanin, Enguerrand David, Etual Ojeda, Fergus Mulvany, Fred Dobbs, Greg J Grady, Greg Jacklin, Guy Beauregard, Guy-Olivier Deveau, Igor Akimov, Ilya Filimontsev, Ivan Zverev, Jeroen Advocaat, Jihoon Choi, Johannes Hogebrink, JOOheng Tan, Joris Kivits, Katsuhiko Chaen, Ken Abrams, Ken Barnett, Kirk Rademaker, Leonardo Ugolini, Lucas Bruggemann, Lucinda Wierenga "Sandy Feet", Martin De Zoete, Max Bespalov, Maxim Gazendam, Melineige Beauregard, Nicola Wood, Nikolay Torkhov, Paul Hoggard, Pedro Mira, Peter Vogelaar, Phil Olson, Paulina Siniatkina, Rachel Stubbs, Radovan Zivny, Remy Hoggard, Rogelio Evangelista, Shay Dobbs, Sue McGrew, Susanne Ruseler, Sybren Huizinga, Tae-in Kim, Ted Siebert, Uldis Zarins, EdithStijger, Wilfred Stijger, Yosef Bakir.

I am also grateful to the producers. Without them this experience would have never happened. They are: Yousef Aldaour, Dhari Al Wazzan, Fadi Al Daour

Contents

1.	Introduction	1

Part I

2.	Scheherazade and Shahryar	10
3.	The Three Apples	14
4.	The Little Hunchback	16
5.	The Man Who Stole the Dish of Gold	18
6.	The Angel of Death and the Rich King	20
7.	The Cock and the Fox	21
8.	The Fishes and the Crab	22
9.	The City of Brass	23
10.	The Ox and the Mule	33
11.	The Wolf and the Fox	35
12.	The Birds, the Beasts and the Carpenter	37
13.	The Shipwrecked Woman and the Child	39
14.	The Third Calendar, Son of a King	42
15.	The Sisters Who Were Changed to Dogs	49
16.	The Queen of the Serpents	51

Part II

17.	The Fisherman and the Genie	61
18.	Part 2 - The Tale of the Ensorcelled Prince	66
19.	The Three Princes and the Princess Nouronniha	71
20.	Part 2 - Prince Ahmed and The Fairy Banou	77
21.	Kamar and Budur	85
22.	The Fisherman and The Merman	89
23.	The Talking Bird, The Singing Tree, and The Golden Water	95

Contents

Part III

24.	The Storm	109
25.	The Enchanted Horse	123
26.	The King of Persia and the Princess of the Sea	131
27.	Codadad	135
28.	The Prince and the Ogress	146
29.	The Wall	148

Part IV

30.	Ali Baba and the Forty Thieves	154
31.	Sinbad the Sailor and Sinbad the Porter	172
	The First Voyage	174
	The Second Voyage	182
	The Third Voyage	188
	The Fourth Voyage	196
	The Fifth Voyage	202
	The Sixth Voyage	212
	The Seventh Voyage	220
32.	Sinterklaas	225
33.	Aladdin and the Wonderful Lamp	229

End

34.	The Artists	245
35.	The Design	249
36.	Bibliography	267
37.	Producers	268

Introduction

The Arabian nights originated from stories told along eastern trade routes and were kept alive by the oral tradition. Scholars believe the tales have Indian, Arabic, and Persian origins. These stories were written into the frame narrative of Sheherazade and Shahryar sometime in the 10th to the 12th centuries to form "Alf Layla Wa Layla," Arabic for: 'One thousand nights and a night.' Also known as The 1001 Nights, the stories that make up the collection include many genres: epic fantasy, fairy tales, love stories, quests, murder mysteries, tragic comedies, and even zombies. The frame story of Sheherazade and Shahryar comprises the structure of stories within a story, also seen in modern literature and cinema. A collection written in Arabic existed around the 8th or 9th century. A French translation was first published in 1704 by Antoine Galland. English translations soon followed, with Edward William Lane and Sir Richard Francis Burton publishing translations from Arabic. When you read the abridged versions in this book, you might recognize their story structures and arcs in familiar books, movies, and graphic novels.

Ted, "Great White Buffalo," always prioritized fun in his jobs. This one wasn't all fun, that's what makes it a good story.

Our adventure is another story within the stories of The 1001 Nights. The Sand Sculpture Company was commissioned in 2013 to create the world's largest sand sculpture park. When Ted called me and explained the proposal, I was hesitant and doubtful. The scale of the project was hard to comprehend; 30,000 tons of sand to be staged over a site that was the size of six football fields. We knew that would be extremely challenging, especially in the foreign land of Kuwait. Bravery or bravado led to a signed contract and Ted commissioned me to be the creative director, christening me as "Tembo" (the elephant). Brian, the leopard, one of "The Big Five," ensured the crew had animal call signs for the project. Ted, AKA "Great White Buffalo," always prioritized fun in his jobs. This one wasn't all fun, but that's what makes it a good story.

I first researched The Arabian nights literature extensively for the sculpture park design. Collecting different books and source material, reading for many weeks, and curating hundreds of images to understand these stories from a deeper perspective. I felt this level of

Brian, the leopard, one of "The Big Five", made sure the crew all had animal call signs for the project.

attention was critical for such a high-profile event, and we wanted to present accurate versions of these stories, especially the best-known tales. I sketched concepts for each sculpture. These are showcased in the appendix and seen on the maps at the beginning of each part of this book. These drawings visualized the idea of the sculpture and not necessarily the result. I wanted to encourage the artists to put themselves into this great work. I provided them with shortened versions of the story that matched their sculpture assignments so they could better understand their subject matter. I hoped this would inspire their interpretation and showcase their artistic talent. I had no grand idea I could do better than seventy of the most incredible sand sculptors in the world. This book compiles these shortened stories alongside their companion sand sculptures. Our story of creating the sculpture park is also told through this image-rich and unique presentation of The Arabian Nights.

Bryn modeled the entire park in poundup form so we could do virtual walkthroughs of the design.

The sculptures in this book were made with only sand and water. **Prepare to be wowed.**

I had no grand idea I could do better than seventy of the most incredible sand sculptors in the world.

4

THE ARABIAN NIGHTS ∽ SCULPTURE PARK MAP

Part I

Scheherazade would continue her tales each evening, never finishing but keeping her husband enthralled with story after story for one thousand and one nights. Sculptor - Bob ATISSO

Scheherazade and Shahryar

King Shahryar was a popular and well-loved king. One day, the king's brother executed his wife for having an affair. In mourning, he traveled to seek companionship with his brother, King Shahryar. During his brother's visit, King Shahryar learned of his own wife's infidelity and, in his rage, had her executed. He and his brother went traveling to forget their woes. Along the way, they encountered a sleeping genie with a slave girl. While the genie was sleeping, the girl forced them to pleasure her at the threat of waking the genie, who would surely murder them. This act drove King Shahryar mad, and he declared, "There is no truth in women." When he returned to his kingdom, he ordered his Vizier (chief adviser) to find him a maiden every day. He would then marry her, spend the night with her, and the Vizier would execute them in the morning so these wives had no chance of being untrue to him. This horror went on every night for three years, terrorizing his kingdom. At last, no young girls were left either by fleeing the realm or by execution. All except for two daughters of the Vizier himself, Scheherazade and Dunyazad.

Scheherazade was a learned girl who knew all the tales of the Persians, the Arabs, and the Indians. She had read the philosophers and the poets and knew the stories of kings and common folk. Scheherazade bravely volunteered to be next to marry the wicked king. The Vizir was filled with grief that his jewel of a girl should fall victim to the king. Scheherazade insisted and married king Shahryar, but she had a plan. That night Scheherazade and Shahryar lay in bed. She asked the king if she might bid farewell to her sister and called Dunyazad into the room. As they had planned, Dunyazad asked Scheherazade, "Sister, as this is your final night on earth, tell me one last story to while away the hours of darkness." "With pleasure," said Scheherazade, "if the king wills it." The king was always eager to enlarge his mind with a story, so he gladly gave permission. Scheherazade started to tell a tale but stopped short before finishing the story, causing the king, who had listened well, to put off her execution until the next day. Scheherazade would continue her tales each evening, never finishing but keeping her husband enthralled with story after story for one thousand and one nights. During that time, Scheherazade had three sons. The sultan, now convinced of his wife's fidelity and wisdom, had fallen in love with her and revoked her death sentence. After one thousand and one nights, he did not care that she had no more stories to tell. All he knew was that watching her die would be a pain he could not stand. "You will not be executed. I grant you life for as long as the heavens above allow. Stay with me, and I promise to love you and shower you with all the happiness of marital life," said the king.

Palace Sculptors - Ted Siebert, Martin De Zoete, Fred Dobbs, Maxim Gazendam, Jeroen Advocaat, Delayne Corbett, Greg J Grady
Denis Kleine, Brian Turnbough, Charlotte Kolff, Bruce Phillips, Joris Kivits, Uldis Zarins, Brent Terry, Phil Olson

"You will not be executed. I grant you life for as long as the heavens above allow. Stay with me, and I promise to love you and shower you with all the happiness of marital life," said the king. Figure sculptors - Andrey Vazhynskyy & Rachel Stubbs

Upon hearing that his wife had betrayed him, the young man returned home in a rage and cut his wife's throat, hewed off her head and limbs, wrapped the pieces up in a carpet, put it all into a chest, and threw it into the river.

The Three Apples

An old man with a fishing net made an unusual catch. He pulled a heavy chest out of the sea full of palm leaves, a carpet, and a woman cut in nineteen pieces. The Caliph demanded the murderer be found. When Ja'azar got the assignment to find the murderer within three days, he could not fulfill this task. After three days, the Caliph sentenced Ja'afar to hang with forty of his family and companions for not obeying his orders. However, when Ja'afar was about to be hanged, a young man claimed he was the murderer of the lady. When brought before the Caliph, the man gave the details of the chest contents. The Caliph asked for the story behind it.

He told the Caliph that the dead woman was his wife. One day she fell ill, and she asked for an apple. The young man could not find a single apple in the city despite being willing to pay a high sum. He learned that the Commander of the Faithful at Bassorah had apples in his Garden. So he traveled for fifteen days to get them and brought three apples back to his wife. He laid them by her side on the bed, but she had grown so weak she could not even eat the apples.

Later, he saw a man with an apple and asked how he got it. The man told him he got it from his mistress, who told him her husband had brought them from as far away as Bassorah. Upon hearing that his wife had betrayed him, the young man returned home in a rage and cut his wife's throat, hewed off her head and limbs, wrapped the pieces up in a carpet, put it all into a chest, and threw it into the river.

When he returned home, he found his son crying. He told his father that he took one of the apples from his mother and went playing. A man had come to him and stolen his apple. His son cried, tried to appeal to mercy, and gave the man the story of the apples. He told of how far his father had traveled for them and how they were for his ill mother.

Learning the truth, the man mourned for five days until he turned himself in. Now he begged the Caliph to kill him for the unjust deed.

Sculptors - Radovan Zivny & Andrey Vazhynskyy

"Stop, please, in God's name! It is me, a Muslim, who killed this Muslim brother. How can one kill a dead man? I can't let the blood of an innocent Christian stain my hands. Please let him go." Sculptor - Guy-Olivier Deveau

The Little Hunchback

In ancient Kashgar, a tailor lived with his wife on the borders of a great territory. One morning the tailor was working in his shop when a little hunchback sat by the shop's door. He played a tambour and sang many songs. The tailor was so impressed he thought, "I'll take him home. When I am at the shop, he can entertain my wife." The tailor took the little hunchback home in the evening. His wife arranged dinner, and they were introduced. The three of them were having dinner, joking and laughing with each other, when the little hunchback swallowed a fish bone. He started choking, and the tailor patted his back while his wife gave him water, but the little hunchback did not recover and soon lay dead at the dinner table. The two worried that the king's guards would accuse them of murder. So they thought they would make it appear that someone else had caused his death.

They decided to leave the hunchback at the Jewish doctor's residence. They carried the body of the hunchback to the doctor's house and knocked at the door. A maid came down the dark, steep stairway and answered the door. The tailor said, "We have brought a man who is very ill. Tell the doctor to rush down here." The maid went upstairs to call the doctor while the tailor put the hunchback on the stairs in a sitting position and ran away. The doctor came out running to see the ill patient. As he ran out, he tripped over the body of the hunchback, which caused the body to fall down the stairs such that the doctor thought he had killed him. Now it was the doctor's turn to be afraid. He quickly carried the dead body to his wife's chamber, where he told her what had happened. He feared he would have to confess to the murder of the little hunchback. But his wife stopped him. She said, "You'll be foolish to confess and go to prison. Both of us will carry this corpse to our roof. From there, we'll step onto our Muslim neighbor's roof. We'll lower it in through the chimney and into his house." Soon he and his wife carried out their plan successfully.

The Muslim neighbor had a storeroom in his house where he kept his goods, and when the doctor and his wife lowered the dead body of the hunchback through the chimney, that is where it landed. That night when the neighbor entered the storeroom with his lantern, he thought he saw a thief standing by the wall. He picked up a stick and started beating the thief. After a while, when the thief did not respond and lay sideways on the floor, the neighbor thought his brutal beatings had killed him. Now the Muslim asked God for forgiveness and felt very guilty and afraid, so he thought of getting rid of the body so that no one would suspect him. He carried the body to the market. It was night, so no one saw him as he leaned the body against one of the shop's walls, and he crept back home.

Just before dawn, a wealthy Christian merchant was returning from a feast where he had drunk a lot. He was going to the bath to freshen up. He walked hastily because if seen drunk by any other, he would be punished, according to the law of the land. As he walked fast, he jostled against a man who stood by a shop's wall. In his drunken state, the Christian thought it was a thief trying to attack him, so he gave a full-fisted blow to the man's face. The man fell to the ground. Then the Christian started calling loudly for help. A guard patrolling the area came to him

Sculptors Fergus Mulvany and Guy-Olivier Deveau working on their sculptures.

and called the fallen man to get up, but he didn't move. The guard declared, "You are a Christian and killed a devout Muslim. You will be punished for showing disrespect to another religion." And the Christian was put into prison.

After an investigation, it was revealed that the little hunchback had been one of the sultan's favorite royal jesters, so the case was presented in the royal court. The sultan was enraged that so he sentenced the Christian to death. Soon the town crier announced that he would be hanged publicly. A crowd gathered at the gallows to witness his death. Just as the hangman was about to tighten the rope around the merchant's neck, a man came rushing through the crowd, "Stop, please, in God's name! It is me, a Muslim, who killed this Muslim brother. How can one kill a dead man? I can't let the blood of an innocent Christian stain my hands. Please let him go." The crowd and guards then heard the Muslim's story. Thus, the Christian stepped down, and the guards prepared to hang the Muslim. As the Muslim approached the gallows, someone screamed, "Guards, stop. I confess to this crime." There was a roar of confusion in the crowd. Then a man emerged. He was the Jewish doctor and said, "Please spare my Muslim friend's life, for it is I who caused the jester's death." The Jewish doctor confessed to the death of the hunchback. The guards and the crowd were surprised at the turn of events. Then they again fell silent as the hangman tightened the noose around the Jewish doctor's neck. Just then, the tailor rushed to the gallows and said, "That noose is for my neck and not for the innocent Jewish doctor, for I am the real culprit." As the tailor told his story, the people murmured in surprise and confusion. Then the hangman freed the Jewish doctor.

Meanwhile, the sultan learned about the drama unfolding at the gallows. He summoned all to his court. Once they arrived, the sultan heard everyone's story. Then he understood that the hunchbacked had died from choking on the fish bone and that the accused stood innocent, so he set them all free.

The Man Who Stole the Dish of Gold

There was a man who had accumulated debts and left his family. He wandered at random until he came to a city. He entered it in a state of hopelessness and despair. When he saw a company of wealthy revelers, he followed them until they reached a house like a royal palace. He entered with them and, for fear of his life, sat down in a place far off where no one could see him. While he was sitting, in came a man with four dogs, wearing collars of gold and chains of silver. The man tied up each dog and set four gold dishes full of rich meats before the dogs. Then he left while the poor man began to eye the food with hunger. One of the dogs looked at him, and signed to him with his forepaw to take what food was left and pushed the dish toward him. So, the man took the dish and, leaving the house and went on his way seeing that no one followed him.

He journeyed to another city, where he sold the dish, bought stock in trade, and returned to his own town. There he sold his goods, paid his debts, became affluent, and rose to prosperity. After some years, he said to himself, "I shall repay the owner of the dish and carry him a handsome present the value of that which his dog bestowed upon me." So he set out, journeying day and night until he came to that city. He sought the place where the man lived but instead found ruins. At this, his heart and soul were troubled. Seeing a wretched man, he said, "What have time and fortune done with the lord of this place, and what is the cause of the ruin?" The wretch said, "I was the lord of this place. I was the proud possessor of all its grandeur. Time turned and did away my wealth and took from me that it had lent. But there must be some reason for this question, so tell me." The wealthy man told him the whole story. He added, "I have brought thee a present, and the price of thy dish of gold which I took; for it was the cause of my affluence after poverty." But the man shook his head and answered: "If a dog of mine made a generous gift to thee of a dish of gold, why should I take back the price of what the dog gave? If I were in extreme unease and misery, I would not accept! Return whence thou came in health and safety." The merchant kissed his feet and took leave of him, reciting this couplet: "Men and dogs together are all gone by. So peace be with all of them, dogs and men!"

"I shall repay the owner of the dish and carry him a handsome present the value of that which his dog bestowed upon me."
Sculptor - Benjamin Probanza

The Angel of Death and the Rich King

An enormously wealthy king had heaped up treasure beyond count and spent all his efforts amassing his wealth. One day, he was hosting a large banquet when there came a knock at the gate. A man entered clad in tattered rags as if he were one to beg for food. The servants ran at the stranger with weapons to chase him away, but he cried out at them, saying, "Abide in your places, for I am the Angel of Death and I come for the king." Then the king said, "Take a substitute in my stead." But the Angel answered, "I will take no substitute, and I come to make severance between thee and the riches thou hast heaped up and treasured." The king wept and groaned, saying, "May God curse the treasure that has deluded and undone me!" Then the treasure spoke, "Why dost thou curse me? Curse thyself, for thou didst garner me and hoard me, never gave thanks for me, but was ungrateful and never spent us on good things. Then the Angel of Death took the soul of the king, and he fell from his throne, dead.

Then the Angel of Death took the soul of the King, and he fell from his throne, dead.
Sculptor - Fergus Mulvany

Then the treasure spoke, "Why dost thou curse me? Curse thyself."
Sculptor - Joris Kivits

The Cock and the Fox

An old Rooster perched on a high wall so his enemies could not reach him. A fox came by, looked up, and said, "Peace be with you. You are an excellent friend and brother." But the cock would not reply to him. The fox again said, "Why are you not replying to my greetings or talking to me?" Still, the cock ignored him. The fox again spoke, "The king of the beasts, the Lion, and the king of the birds, the Eagle, have ordered everybody to live in friendship. They have asked me to tell everyone. So, you can come down safely."

The cock did not pay any attention to him. The fox grew impatient, "Why are you not acknowledging me." The cock replied, " I heard you, but I see more pressing matters. I see a dust cloud forming from the falcons towering in circles." Hearing this, the fox got frightened, and the cock continued, "I can see them coming straight towards us."

As the fox heard this, he cried, "I must leave you now." He ran away as fast as he could. The cock cried out, "Why do you run when you have nothing to fear of anyone?" The fox replied, "I am afraid of the falcons, for they are not my friends." The cock replied, "Didn't you tell me that the King has proclaimed peace amongst all the beasts and the birds?" The fox said, "The Falcons were not present when this proclamation was made." And the fox ran away. The Rooster crowed with laughter as he had outwitted his foe, the fox.

The cock cried out, "Why do you run when you have nothing to fear of anyone?" Sculptors - Nicola Wood & Rachel Stubbs

The Fishes and the Crab

There was a pond with several Fish, and the water level dwindled away until barely enough remained to suffice them. One of them, who was the chief in wit, cried, "Let us consult the Crab and ask his advice," whom they found squatted in his hole. They told him their case and that destruction would befall them when the water dried up. The Crab bowed his head awhile and said, "Know ye not that Allah appointed each of his creatures a fixed term of life and an allotted provision. How then shall we burden ourselves with concern for which is his secret purpose? Better to seek the aid of Allah Almighty and pray to him to deliver us from our difficulties. So 'tis my counsel that we take patience and await what Allah shall do with us." All the fishes returned, and in a few days, a violent rain filled the pond even fuller than before.

"Tis my counsel that we take patience and await what Allah shall do with us." Sculptors - *Agnese Rudzite Kirillova & Uldis Zarins*

The City of Brass

Once, a Caliph in Damascus sat in his palace talking with his sultan and kings. The talk took a turn toward the legends of Lord Solomon. The Caliph said, "The Lord bestowed special powers on Solomon that he could imprison Jinn, Marids, and Devils in flasks and seal them in with his ring." Taalib Bin-Sahal said, "Caliph, my grandfather told me a story of taking a ship and crew for Sicily, and a wind drove them off course to a great mountain in a land they did not know. They came in the darkness of night, and as soon as the Sun rose, they saw naked black men coming from a cave. Their king came and welcomed them and they told them all about themselves, and he said, "Do not worry at all. You are safe here." Then he entertained and fed them for three days. Here, they saw a man casting his net to catch fish, and when he pulled it up, there was a flask of copper in his net, stopped with lead and sealed with the signet of Solomon. He broke it open, and out billowed smoke. The smoke turned into a huge giant, and that giant vanished from our sight. The king told them he was one of the Jinn whom Solomon shut in this vessel and cast into the sea. Our fishermen often bring out such bottles." After Taalib's story, the Caliph said, "By Allah, I wish to see some of these Solomonic vessels myself!" Taalib said, "Caliph, it is in your power." The Caliph liked this idea, so he wrote a letter to his Viceroy in Egypt, Moosaa bin-Nusair, requesting his support in searching for Solomonic bottles. He sealed the letter and gave it, along with money for the journey, to Taalib.

They contracted the Sheikh Abd al-Samad as a guide to Upper Egypt. The Sheikh said, " You should know that the road to where you seek is very long and difficult."

The party proceeded first through inhabited lands, then through ruins, then into frightful lands. Sculptor - Calixto Molina

Taalib set out for Cairo, where he delivered the letter to Moosaa bin-Nusair. They contracted the Sheikh as a guide to Upper Egypt. The Sheikh said, "You should know that the road to where you seek is very long and difficult. It is a journey of two years and some months, and the same for returning, and the way is full of hardships." Moosaa took one thousand camels laden with provisions and two thousand cavalry and set out under the leadership of Sheikh Abd al-Samad. The party proceeded first through inhabited lands, then through ruins, then into frightful lands. One year passed when the Sheikh told them they were in a land he did not know. They came to a vast place where they saw something on the horizon, high and black, and from which smoke was rising.

It was a high castle built of black stone. Its door was of China steel, and around it was a thousand steps. Moosaa said, "How is this place without inhabitants?" The Sheikh said, "I have heard of legends of this place. It is on the path to the City of Brass. Between here and your destination, there is a two-month journey. There are facilities and water there." So Moosaa went to the palace with the Sheikh and his people. Arriving at the gate, they found it open. There was a tablet at the doorway engraved with Ionian characters in gold. They entered and came to another gate where more engravings told terrible tales and issued dire warnings.

The whole palace was empty. In its midst stood a large pavilion with a dome rising high in

the air. This pavilion had eight sandalwood doors studded with nails of gold and stars of silver and inlaid with all kinds of precious stones. Then they came to a place where a table had written on it, "At this table, have eaten a thousand kings blind in the right eye, and a thousand kings blind with the left eye, and a thousand kings blind in both eyes, all of whom have departed this world." Then they left the strange palace and came to a high hill. There stood a horseman of brass. He held a spear in his hand. On it was written, "Who comes to me, if you do not know the way to the City of Brass, rub the hand of this rider, and he will turn to its direction." Moosaa rubbed its hand, and it revolved like lightning and stopped in one direction. They took that road and, after crossing a vast tract, came to a human figure out of black stone. He had two great wings and four arms, two of which were like human arms, and the others were like lion's paws, with iron claws. He had a third eye in the middle of his forehead. The Sheikh said, "By Allah, I am afraid of him." Moosaa said, "Do not fear because he is cast in stone." The Sheikh went near him and asked, "What is your name, what are you, and why are you in this manner?" He spoke, "I am an Ifrit of the Jinn Daahish, son of al-Aamash, and I am confined here by Allah. "My story is extraordinary. It goes like this:

"One of the sons of Iblis had an idol of red quartz, and I was its guardian and a King's servant. He had a million warriors under him, and all these were under me too. We were all rebels against Solomon. From the belly of the idol, I served him and commanded the troops. A prophet told Solomon about this, and he demanded the king break the quartz idol. If he would not do this, then he would kill him. So, the king went to the idol, offered sacrifices, and prayed. I said to him, "Do not worry. I will fight and kill him." Hearing my boastful reply, the king waged war. Solomon collected six hundred million demons, mounted them upon his carpet, and flew through the air. Beasts came under him, and the birds flew over him. When he arrived here, he sent for our king, saying, "I

They took that road and, after crossing a vast tract, came to a human figure out of black stone. He had two great wings and four arms, two of which were like human arms, and the others were like lion's paws, with iron claws. He had a third eye in the middle of his forehead.
Sculptor - Guy-Olivier Deveau

The King collected his Jinn and fought bravely with Solomon for two days. On the third day, the troops and I were defeated.
Sculptor - Uldis Zarins

have come. Defend yourself or submit to me. "The King collected all his Jinn and fought bravely with Solomon for two days. On the third day, the troops and I were defeated. I fled from there. Solomon's Vizier followed me for three months until I fell tired, and he overtook me. I was taken to Solomon and he ordered a pillar to be hollowed out. Then he set me in it, chained me, and sealed me in with his signet ring. He asked an angel to guard me, and I will be here until Judgment Day."

The Sheikh asked him, "Are there any of the Ifrits imprisoned in the bottles of brass from the time of Solomon?" "Yes, there are a few in the sea of al-Karkara on the shores where the people from Noah's lineage live." The Sheikh asked, "And which way to the City of Brass and the place where these bottles can be found." The Ifrit directed them there. They journeyed and came to a place in a great blackness with two fires facing each other. Abd al-Samad said, "This is the City of Brass, as it is described in the Book of Hidden Treasures. Its walls are of black stones, and it has two towers of Andalusian brass which look like two fires." They went forward near the city, and it looked to them as if it were a piece of a mountain or a mass of cast iron. Impenetrable for the height of its walls, while its buildings were magnificent. They looked for an entrance but could not find even a trace of

"Its walls are of black stones, and it has two towers of Andalusian brass which look like two fires." They went forward near the city, and it looked to them as if it were a piece of a mountain or a mass of cast iron. Impenetrable for the height of its walls.
Sculptors - Brent Terry, Tae-in Kim & Jihoon Choi

an opening in the wall. Moosaa asked one of his men to go around the city to search for an opening. He mounted on his camel, took the provision with him, and rode round it for two days and two nights but found the wall as if it were one rock. So Moosaa took Taalib and Abd al-Samad and ascended the highest hill, which overlooked the city. When they reached the top, they looked at the city with beautiful houses and mansions, flowers and streams and trees, but the city was empty and still. On the hill Moosaa found seven tablets of white marble. Written on them were warnings and tales of woe.

Ignoring the warnings, he ordered his people to build a ladder of wood and banded with iron to scale the wall. One of his men volunteered to go up the ladder. When he reached the top he cried out, "By Allah, you are fair." And cast himself down into the place. Then another man said, "Let me go up and open the gate for you." He climbed up the ladder, and no sooner had he reached the top when he cried out and jumped down to his death. A third one said, "Maybe I am steadier than the previous ones." He also climbed the ladder and jumped to his death. It continued till a dozen people jumped into the city and died. Then the Sheikh said, "This is reserved only for me and will only be accomplished at my hands." So, he went up, calling Allah's name and reciting the safety verses. The Sheikh stayed there for an hour, and then he cried out, "Do not fear now. No hurt will fall on you. Allah has warded off the demons through me." Moosaa asked him, "What did you see?" The Sheikh said, "I saw ten maidens who signed to me, "Come to us." And it seemed to me as if there was a lake of water below me, so I thought to throw myself down when I saw my twelve companions lying dead, so I controlled myself from jumping down."

The Sheikh walked along the wall and came to two towers and saw two golden gates without any means of opening. He gazed at them for some time and found a horseman in the middle of one gate pointing with something written on his palm. He read the words: "O you who comes to this place, you would enter this city by turning the pin in my navel twelve times, and the gate will open." He examined the horseman, found a gold pin in his navel, and turned it twelve times. The horseman revolved like lightning, and the gate swung open with a noise like thunder. He entered the gate and found himself in a long passage. At the end was a room furnished with benches on which dead men sat. Here he found the city's main gate, secured with iron bars, locks, bolts, and chains. He took the dead men's keys and opened the locks. They were about to enter, but Moosaa stopped them, "If we all go in at once, we will not be safe. Let only half of us enter first." They saw many kinds of people in there, but they all were dead. Then they came to a marketplace. The shops were open, their scales were hung, and merchants were sitting dead. After the markets, there came a magnificently decorated palace, but the men in it were dead. Then they went into the inner court. There they found four pavilions. They entered the first and found it full of gold, silver, pearls, and other precious stones. The second pavilion was full of arms and armor, helmets, and swords. The third was full of weapons adorned with gold and silver. The fourth pavilion was full of eating and drinking vessels of gold and silver with platters of crystal and goblets set with fine pearls. They took all that they could.

As they walked, they found a door that led to a saloon. There was a couch on which a girl was lying. She looked so lively that Moosaa said, "Peace be with you, O damsel." But Taalib said,

Taalib asked him, "Shall we leave what is on this damsel's body?" Moosaa said, "Didn't you read what this lady has said on the tablet." Sculptors - Remy and Paul Hoggard

"She is dead. Her corpse has been embalmed with exceeding art." There were two warrior statues on the steps to where this lady lay. The first had a steel mace, and the second held a sword. On one of the steps lay a golden tablet on which was written, "Whoever enters our city, let him take all the treasure he can, but do not touch anything which is on my body. It is the covering of my shame and the outfit for the last journey." Moosaa wept reading this, then asked his people to fetch the camels and load them with treasures, vases, and jewels. Taalib asked him, "Shall we leave what is on this damsel's body?" Moosaa said, "Didn't you read what this lady has said on the tablet." Taalib asked, "Should we leave all this here just because it is written on a tablet? What will she do of these ornaments?" So he mounted the steps of the couch, but as he reached for the woman, the mace bearer struck him on his back, and the other struck him with the sword, and he dropped down dead. Moosaa said, "Greed kills the man."

Moosaa ordered his troops to load all the treasure. They walked along the shore for a month till they came in sight of a high mountain full of

There were two warrior statues on the steps to the couch on which this lady lay. The first had a steel mace, and the second held the sword. Sculptor - Bob ATISSO

caves where there lived a black tribe clad in hides speaking an unknown tongue. They dismounted, set down their loads, and pitched their tents. At the same time, their king came to them. He asked Moosaa, "Are you men or Jinn?" Moosaa replied, "We are men, and come in peace." The king said, "What brings you here to this land?" Moosaa said, "We are the officers of the Caliph of al-Islam Abd al-Malik bin Marvaan who has heard about Solomon and his power on all Jinn and beasts and birds. He shut the Jinn into flasks of brass and cast them into the sea of al-Karkar. We have heard that this sea is your land, so our Caliph has sent us to bring him some of those flasks. We ask your cooperation." The king said, "With pleasure." He took them to his guest house, treated them with the utmost honor, and furnished them with all they needed. He ordered his people to bring some flasks. They dove into the sea and brought back twelve flasks. Moosaa and his crew took leave of the king and set upon the journey back to their own country. They traveled until they came to Damascus, where Moosaa went to the Caliph and relayed all that he had seen and heard. The Caliph said, "I wish I had been with you!" Then they opened the bottles, and the genies came out, saying, "We repent and are in your service. Never again will we return to this prison."

Then they opened the bottles, and the genies came out, saying, "We repent and are in your service. Never again will we return to this prison." Sculptor - Dmitry Klimenko

The Ox and the Mule

There was once a merchant who was rich in cattle and camels. Allah had given him the power to understand the speech of animals and birds. One evening he was sitting by the stables when he heard his bull talking, "Oh donkey, " he was saying, "How come you have the best barley, the freshest water, and the easiest life? You stay all day indoors while the men wait upon you like servants, sweeping your stall and brushing your coat until it shines. But, they lead me out to work at the break of dawn. The men make me wear a yoke around my shoulders. They crack whips over my back and force me to pull the plow through the fields from morning to sunset. My life is nothing but toil. But your duties are light and pleasant. Once every two weeks, you carry the master to the market on your back. He is not fat, and the burden is not great, and he likes you and appreciates you. Your life is so much better than mine. Donkey, how can I live like you?"

You can imagine how intrigued the merchant was by this conversation. He tuned in his ears to ensure he did not miss a word. The donkey laughed with a great Eeeeeore! And replied to the bull, "Why, you big old fool! You are ten times as strong as I am, yet you let the humans treat you without respect. Do not show a willingness to work, or the men will take advantage of you. When they come in the morning and try to place the yoke over your neck, toss your head. When they try to drive you out to the fields, lie down in your manger and refuse to move. They cannot make a great hulk like you even budge an inch if you do not wish it. Bellow, like you are angry or ill. They will soon get the message and leave you alone."

The merchant heard the donkey's words and was curious to see whether the bull would heed his advice. It was not entirely surprising to him when, the following day, the steward came to him, looking anxious and worried, and said, "Sir, something has got into the bull. Perhaps it is a demon, or perhaps he is ill. When we try to put the yoke on his neck, he tosses his head, so we cannot manage it. When we try to drive him out of the stall, he bellows at us and paws the ground with his front leg. And now, finally, he is lying down in the straw. What are we to do, sir? We cannot force the bull into the fields if he does not wish it. He is far too big and strong." The merchant understood only too well what was wrong with the bull. The merchant had already decided he would teach the donkey a lesson. He said to his steward, "If the bull does not wish to work, then let him take a well-earned rest. Put the yoke on the donkey, and make him plow the fields today, for it is only fair that he takes his share of the hard work."

Following their master's orders, the men placed the yoke over the shoulders of the donkey, and they dragged him out to the fields. When he dug his heels into the ground, they cracked whips over his back. He had no choice but to pull the heavy plow through the earth all day. When he returned to his stall in the evening, his legs were weak, and his whole body was weary. He saw the bull lying in the clean straw, looking rested and happy. Indeed the bull welcomed him home cheerily, saying, "My true friend, I have done exactly as you advised me, and today I have enjoyed rest, water, and good food. I thank you from the bottom of my bull's heart for your wisdom. " But the donkey had little to say. He took

Now I must play a trick on him, or I shall suffer again. So now he said to the bull: "My friend, I have advised you well once, and now I shall advise you again. Yesterday, I heard the merchant speaking to his steward. He ordered that if the bull does not work, he should take him to the butcher and make meat for the poor people and leather for shoes and saddles."
Sculptor - Guy Beauregard

a long drink of water and lay down in his hay, utterly exhausted by his day's work. When the morning came, the merchant rose early to see how his animals had fared. He peeped in through the window of the stables and saw that the bull was swishing his tale happily. The donkey was still lying in his straw, feeling less than his best. The bull said, "I am so looking forward to another day's rest. When the men come for me, I shall again toss my head, paw the ground, and bellow with my great voice. Then I shall lie down, and they will not be able to lead me out to work." When he heard the bull's plans, the donkey reflected, "Foolish me! I gave the bull good advice but did not foresee how I would pay for it. Now I must play a trick on him, or I shall suffer again." So now he said to the bull, "My friend, I have advised you well once, and now I shall advise you again. Do not toss your head and refuse to take the yoke when the men come today. Nor should you bellow with rage or lie down in your straw if you care for your life. Yesterday, I heard the merchant speaking to his steward. He ordered that if the bull does not work, he should take him to the butcher and make meat and leather for shoes and saddles." The bull thanked the donkey for once again giving him wise advice, and when the men came to fetch him from the stall, he willingly took the yoke and went out to the fields for his day's work.

The Wolf and the Fox

The Wolf and the Fox were like brothers and lived together in one den. The Wolf was far bigger and more powerful than the Fox, and he thought himself the better of the pair. The Fox, though smaller, thought he was much smarter than the Wolf, and he resented how the Wolf acted like he was the boss. He always showed the Wolf the greatest respect and flattered him often. Inwardly, the Fox hated him and was looking for revenge.

One day, the Fox was skulking along the vineyard wall, looking for a way to sneak in and steal some grapes. He found a hole large enough to creep through. At first, he was delighted, and then he thought, "This is too good to be true. I think The Son of Adam is plotting something." He stretched through the hole and gently tapped the ground on the other side with his paw. It was just as he thought. The man had laid sticks and leaves across a deep pit. It was a trap to catch a thief. The Fox ran back to the den with a spring in his step. He told the Wolf, "I have found an easy way into the vineyard. You can sneak in and fill your belly with man's juicy grapes." The Wolf had no reason to doubt Fox's words, and he trotted off to the vineyard. He found the hole in the wall and crawled through it. On the other side, he fell through the sticks, straight into the trap. The Fox saw his friend's misfortune, and he was jubilant. "At last, fortune has taken pity on me! Greed has pulled the Wolf down to his doom!" With tears in his eyes, he peered over the edge of the pit and saw the sorrowful Wolf looking up at him, "My one true friend," said the Wolf, "I see that you are crying for me." No!" Laughed the Fox. "I am crying because I am sad you didn't fall into this deep hole sooner." These cruel words stunned and hurt The Wolf even more than his fall had done. He replied: "Have mercy on your brother. Go and bring help." "You stupid, witless beast, why should I help you who have been a tyrant over me?" "But, but," pleaded the Wolf, "You have always professed your love for me. How can you turn against me like this?" "Oh, you deluded, self-deceiving fool," jeered the Fox, "That was my fear talking, not my heart. In truth, I hate you, for you are a bully and a brute." Still unable to fully believe these words, the Wolf, half thinking that his friend was joking, said, "I pray, do not speak to me with the tongue of an enemy. The wise poet once said: 'Forgiveness is noble, and kindness is the best of treasures.'" "Oh, now you beg and scrape," said the Fox, "But that is only because you are down in the dark hole, and I am up here in the sun. If you rescue me from this pit, I shall repent my ways!" Howled the Wolf. But the Fox just laughed at him.

At last, the Wolf realized that there was no hope, and all was lost. He began to weep and howl more piteously than ever. The Fox still had a place in his heart not filled with hatred. At last, he was moved. He looked over to the hole and said: "My friend. Why are you crying so? I was only joking when I said those words. Here, take my tail and pull yourself out." He dangled his red bushy tail into the hole for the Wolf to take hold of. But the Wolf, full of desire for revenge, did not use the tail to save himself. Instead, he seized it and pulled the Fox down into the hole with him. He growled

"The wise poet once said: 'Forgiveness is noble, and kindness is the best of treasures." Sculptors - Joris Kivits and Bouke Atema

triumphantly, "So now you have fallen into the snare of your own intent, you traitor, and in it, you shall share my fate!" The Fox, full of fear, began to beg, "Oh Brave and powerful master, do not strike me and kill me now, or you will not benefit from my plan, and we shall both die." The Wolf, already feeling a little calmer, began to regret that he had not saved himself when he had the chance and asked, "How exactly do you propose to save us?" "Easy," said the Fox, "Lift me up on your head, and I can scramble out of this pit. I will run and fetch a vine to use as a rope to help you climb out." But the Wolf shook his shaggy head and said: "Fox, I am not the fool you take me to be. As the poet said, The worst of enemies is your nearest friend. Greet him with a smiling face but be ready to do battle with him. And that is why I do not trust your words. We shall die together." "Wise words," said the Fox, "But trust is the glue of friendship. Without trust, each one of us is on his own. Without trust, there can be no working together. The choice is yours. Trust me or die." The Wolf, who did hope to live, saw that he had little to lose by helping the Fox, so he lifted him up on his head. The Fox grasped at the hole's edge with his claws, got a hold of a vine, and scrambled up into the daylight. "Be sure to keep your word," He called up the Wolf, "Run and fetch that rope and pull me out." "Ha! Ha!" Cried the Fox, not a Chance! If I help you, you will take your revenge and kill me." He ran up the hill towards the village when the man came out holding a rake in his hand. He saw the Fox and started to chase him. The Fox turned and ran, meaning to lead him to the pit where he would find the Wolf and kill him. But as he ran, the Fox thought, "Is it not sad that we are all alone in this world and can trust no one." And when he reached the pit, he dangled his tail down into the hole once again and said: "Wolf, quick, pull yourself out by my tail. If you drag me down into the pit again, we are both dead because the man is no more than a minute away. Either we live or die together." And the Wolf, seeing that he had but one chance to live, pulled himself out by the Fox's tail and ran for the woods. The Fox ran too, but in a different direction, and they never saw each other again.

The Birds, the Beasts and the Carpenter

A duck met a lion sitting at the door of a cave. He asked him, "Why are you in a cave?" The lion said, "My father warned me about man. He told me not to trust him. He can take fish out of the sea, shoot the birds, and even trap the elephant." The duck said, "I will take asylum with you because you are powerful and can kill him if you will it. After all, you are the king of the beasts." They journeyed together on the road and came across a donkey. The lion asked, "What are you doing here?" He said, "I am fleeing from man. I fear he will ride on me, make me run more than my strength, and then beat me. I saw a man in the morning, and I am going where he cannot find me." The lion said to the donkey, "Fear not of man. I will protect you!" They then met a horse and asked him, "Why are you running away?" The horse said, "I am fleeing from man." The lion said, "You are such a majestic animal, and you fear man?" The horse laughed, saying, "It is far from my power to overcome him. He can bind me, ride me, and when I am old and weak, he sells me to the miller." The lion said, "I am not afraid of man. If I see him, I will eat him!" They then met a furious camel. The lion asked, "What makes you run so fast?" "I am fleeing from a man." The lion asked, "How come, being so huge, you fear man? You can kill him if you kick him even with one foot." The camel said, "You don't know him. He puts me through hard labor all day and night. When I am old and weak, he sells me to the knacker who kills me and sells my skin and flesh." The lion said, "Wait a while, Camel, and you will see how I tear the man and give his flesh to you to eat."

A cloud of dust rose, and a lean man appeared out of it carrying a basket of carpenter's tools on his shoulder, a branch of a tree, and eight planks on his head. The duck collapsed from fear, and the other animals ran, but the young lion rose and walked forward to meet him. The man said, "O king, Please protect me from mischief." He stood before him, wailing. The lion said, "I will save you from your fear. Who has done you what, and what are you?" The man said, "I am a carpenter, but a man has wronged me, and by next morning he will be here." The lion asked, "Tell me, where are you going?" "I was going to the lynx, for when he heard that man had set foot in this forest, he feared for himself. He sent for me to make a house where he could live safely, so I am taking these planks to make a house for him." The young lion envied the lynx and said, "First make a house for me. Then you may go to the lynx." The carpenter replied, "I cannot make you a house unless I have made one for Lynx." The lion replied, "I will not let you leave this place until you build

Sculptor - Andrius Petkus

"What is this narrow house you have made for me? Let me out." The carpenter laughed, "Now you have fallen into the trap, and there is no escape from here." When the lion cub heard this, he knew that this was the man he had heard about.

me a house of these planks." And he sprang upon him, knocked the basket off his shoulder, and threw him down on the ground.

The carpenter was angry but smilingly said, "OK, I will make the house for you." He made a box from the planks and left the door open. He took out nails and a hammer and said to the lion, "Now, enter your house through this opening so I can fit it to your measure." The lion was happy to see his new house and went inside. Then the man put the lid over the opening and nailed it shut. The lion cried out, "What is this narrow house you have made for me? Let me out." The carpenter laughed, "Now you have fallen into the trap, and there is no escape from here." When the lion heard this, he knew that this was the man he had heard about. Then the man dug a hole and threw the box in it. He put some dry wood on top, and, to the duck's horror, set fire to the box with the lion inside.

38

The Shipwrecked Woman and the Child

A rich woman in the Great Mosque of Mecca struck up a conversation with a poor looking woman in the dark. The poor woman said, "See what is before me." A child was lying asleep and breathing heavily in his slumber. "Being pregnant with this boy, I set forth to make the pilgrimage to this house and took passage in a ship. The waves rose against us, the winds blew, and the vessel

"Whilst we were sailing the seas the ship suddenly stood still. That which stayed us was a great sea beast with this babe on its back, sucking his thumbs so we took him up." Sculptors - Remy & Paul Hoggard

broke up. I saved myself on a plank and gave birth to this child on that bit of wood. While he lay on my bosom and the waves were beating upon me, one of the sailors swam up, climbed on the plank and said, "Yield thy body to me, or I will throw thee into the sea." I fought him, but he persisted with me. I feared him, so I said, "Wait till this babe shall sleep," but he took the child off my lap and threw him into the sea. My heart sank when I saw this deed, and sorrow was upon me. I raised my eyes heavenward and said, "O Thou that interposes between a man and his heart, intervene between me and this brute!" And by Allah, hardly had I spoken when a beast rose out of the sea and snatched him off the plank.

When I saw myself alone, my sorrows redoubled, and I prayed. I abode in this condition a day and a night, and when morning dawned, I caught sight of a vessel shining afar off. The waves and the winds drove me till I reached the ship. The sailors took me up, and I saw my babe was amongst them! I threw myself upon him and said, "O folk, this is my child. How and whence came ye by him?" They said, "Whilst we were sailing the seas, the ship suddenly stood still. That which stayed us was a great sea beast with this babe on its back, sucking his thumbs, so we took him up." I told them my tale and all that had happened to me and returned thanks to my lord. I vowed to Him that I would never stir from His House nor swerve from His service whilst I lived. Since then, I have never asked aught but what He hath given." When she made an end of her story, the rich woman put her hand to her money pouch to give to her, but the poor woman exclaimed, "Have I not told thee of His mercies and the graciousness of His dealings and that I shall take nothing from other than His hand?" And she would accept nothing from her.

The force of attraction became so great that the iron and nails were pulled out of the ships and clung to the mountain sinking the ships. Sculptor - Ilya Filimontsev

The Third Calendar, Son of a King

My name is Agib, and I am the son of a king called Cassib, who reigned over a large kingdom with one of the finest seaport towns in the world. When I succeeded to my father's throne, I commanded a fleet of large ships that explored more distant seas. For forty days, wind and weather were all in our favor, but a terrific storm arose, which made us lose our bearings. We had drifted far off our course and came near a mass of darkness called the Black Mountain. This mountain was composed of adamant, which attracts iron with a tremendous force. As we were helplessly drawn nearer, the force of attraction became so great that the iron and nails were pulled out of the vessels and clung to the mountain, sinking the ships. The mountain was very rugged with a brass dome supported on pillars on the summit. On the top stood a figure of a brass horse with a rider on his back. This rider wore a breastplate with strange figures engraved on it. It is said that as long as this statue remains, vessels will never cease to perish at the foot of the mountain.

I alone managed to grasp a floating plank and was driven ashore by the wind. I found myself at the bottom of some steps which led straight up the mountain. The steps were so narrow and steep that I would have been blown into the sea if the lightest breeze had arisen. When I reached the top, I found the brass dome and the statue but was too weary and was asleep in an instant. In my dreams, an old man appeared to me, saying, "As soon as thou art awake, dig up the ground underfoot, and thou shalt find a bow of brass and three arrows of lead. Shoot the arrows at the statue, and the rider shall tumble into the sea. Then the sea will rise and cover the mountain. A figure of a metal man seated in a boat, having an oar in each hand, will appear. Step on board and let him conduct thee." I woke, sprang up, drew the bow and arrows out of the ground, and with the third shot, the horseman fell with a great crash into the sea, which instantly began to rise. A boat approached me. I stepped silently in, sat down, and the metal man pushed off. He rowed without stopping for nine days, after which land appeared on the horizon. Then the boat and man sank from beneath me and left me floating on the surface. All that day and the next night, I swam, and as my strength began to fail, a huge wave cast me on a flat shore. There seemed to be only me on the island. I saw a ship making directly for the shore and not knowing whether it would contain friends or foes, I hid in the thick branches of a tree. The sailors ran the ship into a creek, where ten slaves landed, carrying spades and pickaxes. In the middle of the island, they stopped and, after digging some time, lifted what seemed to be a trapdoor. They then returned to the vessel two or three times for furniture and provisions and finally were accompanied by an older man, leading a handsome boy of fourteen or fifteen years of age. They all disappeared down the trapdoor and, after remaining below for a few minutes, came up again, but without the boy. This done, they set sail and left. I went down from my tree to where the boy had been buried. I dug up the earth till I reached a large stone with a ring in the center. When removed, this disclosed a flight of stone steps that led to a large, richly furnished room. On a pile of cushions covered with tapestry sat the boy. He looked up, startled at the sight of a

I found myself at the bottom of some steps which led straight up the mountain. The steps were so narrow and steep that I would have been blown into the sea if the lightest breeze had arisen.

stranger. To soothe his fears, I said, "Be not alarmed, sir. I am a king and will do you no harm. On the contrary, perhaps I have been sent here to deliver you out of this tomb." He said, "The reasons that have caused me to be buried in this place are so strange that they will surprise you. My father is a rich merchant, but he never ceased mourning that he had no child to inherit his wealth. One day he dreamed that a son would be born to him, and when this happened, he consulted all the wise men in the kingdom as to the future of the infant. They said the same thing. I was to live happily till I was fifteen when a terrible danger awaited me. If I could avoid it for forty days, I would live on. They added if the statue of the brass horse on the top of the mountain is thrown into the sea by Agib, the

On the top stood a figure of a brass horse with a rider on his back. This rider wore a breastplate with strange figures engraved on it. It is said that as long as this statue remains, vessels will never cease to perish at the foot of the mountain.
Sculptor - Ilya Filimontsev

son of Cassib, then beware, for fifty days later, your son shall fall by his hand! It was only yesterday that the news reached him that the statue of brass had been thrown into the sea, and he at once set about hiding me in this underground chamber, promising to fetch me out when the forty days have passed."

I listened to his story with an inward laugh as to the absurdity, and I hastened to assure my friendship, begging him, in return, to convey me to my own country in his father's ship. I took special care not to inform him that I was the Agib he dreaded. I took on the duties of a servant, and for thirty-nine days, we spent as pleasant an existence as could be expected underground. The morning of the fortieth dawned, and the young man woke in an outburst of joy. "My father may be here at any moment, so make me a bath of hot

"Do not ask us what we saw or what befell us there. We may only say that it cost us each our right eye and imposed our nightly penance upon us."

water, change my clothes, and be ready to receive him." I fetched the water and washed him. Then he begged me to bring him a melon that he might eat and refresh himself. I chose a fine melon but could find no knife to cut it with. "Look in the cornice over my head," It was so high above me that I had difficulty reaching it, and catching my foot in the covering of the bed, I slipped and fell right upon the young man, the knife going straight into his heart. At this awful sight, I shrieked aloud in my grief. I threw myself on the ground in sorrow. Then, fearing to be punished as his murderer, I raised the great stone which blocked the staircase and left the underground chamber. Looking out to sea, I saw the vessel heading for the island, so I concealed myself among the branches of a tree. The old man and his slaves touched land and walked quickly towards the entrance to the underground chamber, but when they saw that the earth had been disturbed, they paused and changed color. In silence, they all went down and called to the youth by name, then, for a moment, I heard no more. Suddenly a fearful scream filled the air. They buried the boy, returned to the ship with great sorrow, and sailed out to sea.

So once more, I was alone, and for a whole month, I searched for some chance of escape. One day it struck me that my prison had grown much larger and that the mainland seemed nearer. It was almost too good to be true. I watched a little longer: there was no doubt about it, and soon there was only a tiny stream for me to cross. Far in front of me, I caught sight of a castle of red copper. I made haste and, after some miles, stood before it and gazed at it in astonishment. There came towards me a tall old man, accompanied by ten young men, all handsome and all blind of the right eye. They greeted me warmly and inquired what had brought me there. When I finished telling my story, the young men begged me to go to the castle, and I accepted their offer. We came at length into a large hall furnished with ten small blue sofas and another sofa in the middle for the old man. As none of the sofas could hold more than one person, they bade me place on the carpet to ask no questions about anything I should see. After a while, the old man rose and brought in supper, which I ate heartily. He rose and went to a closet, bringing out ten basins covered in blue. He set one before each of the young men. The basins were filled with ashes, coal dust, and lamp-black. The young men mixed these all together and smeared them over their heads and faces. They wept and beat their breasts, crying, "This is the fruit of idleness and our wicked lives." This ceremony lasted nearly the whole night, and when it stopped, they washed, put on fresh clothes, and lay down to sleep. All this while, my curiosity almost seemed to burn a hole in me. The following day, when we went out to walk, I said to them, "Gentlemen, I must disobey your wishes. You do such actions as only madmen could be capable of. I cannot forbear asking, 'Why do you daub your faces with black, and how it is you are all blind of one eye?'" But they only answered that it was none of my business. When night came, and the same ceremony was repeated, I implored them to let me know the meaning of it all. "It is for your own sake that we have not granted your request. To preserve you from our unfortunate fate." I answered that whatever the consequence, I wished to satisfy my curiosity. On hearing my determination, my ten hosts then took a sheep, killed it, and handed me a knife. "We must sew you into this sheepskin and then leave you. A bird of monstrous size called a roc, will snatch you up,

"The Golden Door alone is forbidden to open, if you value your peace and the happiness of your life." Sculptor - Greg J Grady

carry you into the sky, and lay you on the top of a mountain. Cut the skin with the knife and throw it off when you are on the ground. As soon as the roc sees you, he will fly away from fear, but you must walk on till you come to a castle with a golden gate studded with jewels. Enter boldly at the gate, which always stands open. Do not ask us what we saw or what befell us there. We may only say that it cost us each our right eye and imposed our nightly penance upon us." I did as they described and found the castle. Never could I have imagined anything so glorious. The gate led into a square court, into which opened a hundred doors, ninety-nine of them being of rare woods and one of gold.

Through these doors, I caught glimpses of splendid gardens or rich storehouses. Entering one of the doors standing open, I found myself in a vast hall where forty young ladies, magnificently dressed and of perfect beauty, were reclining. As soon as they saw me, they rose and uttered words of welcome and even forced me to take a seat that was higher than their own. One brought me splendid garments, another filled a basin with scented water and poured it over my hands, and the rest busied themselves with preparing refreshments. After I had eaten and drunk of the most delicate food and rarest wines, the ladies crowded around me and begged me to tell them

all my adventures. By the time I had finished, night had fallen, and we then sat down to a supper of dried fruits and sweetmeats, after which some sang, and others danced. At length, one of the ladies informed me it was midnight and that she would conduct me to the room that had been prepared for me. Then, bidding me good night, I was left to sleep.

I spent the next thirty-nine days in much the same way as the first, but one morning instead of looking cheerful and smiling, they were in floods of tears. "Prince, we must leave you. Most likely, we shall never see you again, but if you have sufficient self-command, perhaps we may yet look forward to a meeting." Ladies," I replied, "what is the meaning of these strange words?" "We are all princesses, each a king's daughter. We live in this castle together, in the way that you have seen, but at the end of every year, secret duties call us away for forty days. The time has now come. Before we depart, we will leave you our keys so you may not lack entertainment during our absence. But one thing we would ask of you. The Golden Door alone is forbidden to open if you value your peace and the happiness of your life." Weeping, I assured them of my prudence, and after embracing me tenderly, they went their ways. Every day I opened two or three fresh doors, each of which contained so many curious things behind it that I had no chance of feeling dull. Sometimes it was an orchard, and sometimes, it was a court planted with roses, jasmine, daffodils, hyacinths, anemones, and a thousand other flowers. Or it would be an aviary or a treasury heaped up with precious stones. Thirty-nine days passed, and I had explored every corner, save only the room that was shut in by the Golden Door. I stood before the forbidden place for some time when inspiration struck me. I didn't need to enter the chamber just because I unlocked the door. I could stand outside and view whatever hidden wonders might be therein. Arguing against my conscience, I turned the key when a smell rushed out that overcame me completely, and I fell fainting across the threshold. Instead of being warned by this, I shook off the effects of the perfume and then entered boldly. I found myself in a large, vaulted room, scented with aloes and ambergris, lit with golden candle sticks and silver lamps that hung from the ceiling. A great black horse stood in one corner, the most handsome animal I had ever seen. His saddle and bridle were of gold. I led the animal into the open air, then jumped on his back and shook the reins. He spread his wings (which I had not perceived before) and flew up with me straight into the sky. When he had reached a prodigious height, he darted back to earth and landed on the terrace belonging to a castle, shaking me violently off and giving me such a fierce blow with his tail that he knocked out my right eye.

Half-stunned, I rose to my feet, thinking of what had befallen the ten young men as I watched the horse soar into the clouds. I left the terrace and wandered until I came to the hall with the ten blue sofas against the wall. The ten young men came in soon after, accompanied by the old man. They greeted me kindly and said, "We should all be enjoying the same happiness had we not opened the Golden Door while the princesses were absent. We would gladly receive you among us, but we have already told you this is impossible. Depart, therefore, and go." They told me how I was to travel, and I left them blind in one eye and greatly humbled.

The Sisters Who Were Changed to Dogs

A woman beat her two dogs with a whip only to pity them afterward. When asked why she explained: My story is extraordinary. These two dogs are my eldest sisters. When my father and mother died, they left my sisters and me an equal share of their estate. My sisters married and lived with their husbands, who were merchants. My brothers-in-law spent all their money, became bankrupt, and deserted my sisters for foreign lands. My eldest sister returned to me, and I treated her with kindness. She stayed with me, and we shared the wealth that I had. Shortly after, my second sister also came to me, in a sorrier condition. I treated her honorably. After a while, they said that they wanted to marry again and married without my consent. I gave them a dowry and clothes. Their husbands took whatever they could and then left them. They returned, and I took them in and treated them kindlier than before.

One year passed by when I decided to sell my things. I loaded a large ship with merchandise for a voyage and asked my sisters whether they would accompany me. They said yes, so I divided my money into two parts - one to take with me and the other to be left behind so we could return safely and start our lives again if any accident happened. We set off on our voyage and became lost at sea. For ten days, we were astray until we saw a city. Our captain decided to rest there for a few days, store provisions, and proceed further. We entered the city and saw men carrying sticks, but they became stone as we went near them. Then we entered the city and found all the people turned into black stone. We were awestruck and went through the market streets where the goods, gold, and silver were lying. I went up to the castle and found the king seated among his people, but as I went near him, all became black stone. I saw the queen, but she also turned into black stone.

The night fell. I thought of leaving the place, but I forgot the way, so I wrapped myself in a coverlet but could not sleep. When midnight came, I heard a voice chanting the Quran. I followed the voice and came to a closet. Two candles were burning there. There was a copy of the Quran kept on its stand, and a man was reading from it. I was surprised to see him alone and alive in this stone city. I asked him, "What do you read from Quran?" He replied, "First, you tell me, how did you come here? And then I will tell you what has befallen the people of this city and me." So, I told him my story and asked his own. He said, "This city was the capital. My father was the king whom you saw on the throne. All the people of this city worshiped fire. There lived an old Muslim woman who worshiped Allah. When I grew well, my father handed me over to her, saying, "Take him, educate him, and teach him the rules of our faith." So she taught me the tenets of Islam." When I had mastered this much knowledge, she asked me to hide it even from my father unless he slew me. After that woman died, I came here. One day the people heard a voice of a crier, "Leave worshiping Fire, and worship Allah."This went on for years, but they continued to worship fire until one day, the wrath of the Heavens descended upon them - they all turned into black stones. None were saved except me, who was engaged in my prayers." I asked him, "Will you come to the city of Baghdad? I will be your handmaid, the head of the family, and

I picked up a large stone and threw it on the head of the dragon. He died, and the serpent opened her wings and flew away
Sculptors - Nikolay Torkhov & Paulina Siniatkina

mistress over men and servants. Destiny brought me here to meet you." But when my two sisters (these dogs) saw my young lover, they were jealous and plotted against me.

We embarked on the ship, and in the evening, when we had gone to sleep, my sisters lifted me with my bed and threw me into the sea. They did this to the young prince too. He could not swim, so he drowned. When I awoke, I found myself in the ocean. I found a piece of timber I held to until I landed on an island. I spent the night on the island and found a path leading to the mainland in the morning. When I was near the city, a very thick serpent came near to me. A dragon was following her and attacked the snake, I took pity on her, so I picked up a large stone and threw it at the head of the dragon. He died, and the serpent opened her wings and flew away. I slept where I was, and when I woke up, a woman washed my feet, and two dogs stood by her side. I asked her, "Who are you?" She answered, "I am the serpent for whom you did a good deed. You killed the dragon. I am a Geneya, and she was a Genie. As soon as you freed me, I flew to the ship where your sisters threw you into the sea. I moved everything to your house, sank the ship, and changed your sisters into these black dogs. "The serpent continued, "I swear, unless you deal each of these dogs three hundred blows every day, I will change you too to a dog like your sisters." Since then, I have never failed to beat them.

The Queen of the Serpents

Long ago, a Grecian sage called Daniel had many disciples and scholars, and the wise men of Greece were obedient to his bidding. He mused over his lack of a son who might inherit his wisdom and library. After praying to Allah, his wife became pregnant. Soon after, while on a sea voyage, A terrible storm sank his ship. He saved himself and only five pages of all his books by clinging to a plank. When he returned home, very ill, he locked the five pages in a box and gave the key to his wife. "When the boy grows up and asks, "What inheritance did my father leave me?" You shall say, "He gave you these five pages, which, when you have read and understood them, you will be the most learned man of your time." Then he said farewell, heaved one more sigh, and departed the world.

A few days passed, and his widow bore a handsome boy named Hasib Karim al-Din. As he was growing up, he would read nothing, would not master any craft, and there came no work from his hands. She sought out a girl and married him to her, but, despite marriage and the lapse of time, he remained idle as before. One day, some neighbors came to her and said, "Buy him an axe and let him go with us to the mountain and we will cut wood for fuel." They took him to the mountain, where they cut firewood. A violent rainstorm broke over them, and they took refuge in a great cave. Hasib went to a corner of the cavern and, sitting down, dropped his axe to the floor. He noticed the ground sounded hollow under the hatchet, so he dug there and came to a round flagstone with a ring in it. He called his friends, and they pulled up the stone, revealing a cistern full of bees' honey. They filled their coffers with honey, carried it to the streets, and sold the contents. They returned and did this routine for several days, sleeping in the town by night and drawing off the honey by day.

While Hasib was on guard with the honey, the woodcutters plotted to get rid of him so they alone could profit from their find. "We shall let him down into the cistern to bail out the rest of the honey and leave him there." They did so and left him alone in the cistern. Hasib examined the well right and left until he found a crevice from which the light of day shone through. He took out his knife and enlarged the hole till it was big as a window, then crept through it and came to a vast gallery. He came to a huge door of black iron bearing a padlock of silver, wherein was a key of gold. He opened the door and continued until he reached a golden throne upon a hill of steps studded with all manner of gems. He climbed the steps, sat on the throne, and fell to wondering at his settings until drowsiness overcame him, and he fell asleep. He was aroused by loud snorting, hissing, and rustling and opened his eyes. He saw each step occupied by a giant serpent. All their eyes were blazing like live coals. A snake as big as a mule came up to him, bearing a tray of gold on its back, wherein lay another serpent whose face was like that of a woman. She saluted him, and he returned the salutation. She cried out to the other serpents in their language, after which they all fell and did her homage. Then she addressed Hasib, saying, "Have no fear of us, for I am the Queen of the Serpents." "What is thy name?" "Hasib Karim Al-Din." She rejoined, "O Hasib, eat of these fruits, for we have no other meal." He ate his fill, and the Queen said, "Tell me how you came and what hath

He saw each step occupied by a huge serpent. All their eyes were blazing like live coals. Sculptor - Joris Kivits

befallen thee." He told her his story and, in return, she told him her story. Afterwords, Hasib implored the Serpent-Queen saying, "I pray of thy goodness to bring me to the surface of the earth, that I may return to my family." She answered mysteriously, "Hasib, I know the first thing you will do. You will greet thy family and then go to the Hammam bath, and the moment you end your bath, it will cause my death." Desperate to return home, Hasib promised, "I swear I will never again enter the Hammam bath so long as I live. I will only wash at home." The Queen denied his request and kept him a prisoner, with Hasib begging to be returned home. His requests were always refused under the distrust that he might enter the Hammam bath, causing her demise. After a time, he wept, and all the serpents wept on his account and took sympathy on him, asking their Queen, "We beseech thee, bid one of us carry him forth to the surface of the earth, and he will swear an oath never to enter the bath for his long life." The Queen heard their appeal and turned to Hasib and made him swear an oath to her, after which she bade a serpent carry him forth to the surface of the earth.

He walked to the city and, coming to his house, knocked at the door. His mother opened it and, seeing her son, screamed out and threw herself upon him. His wife came out and kissed

A serpent as big as a mule came up to him, bearing a tray of gold on its back, wherein lay another serpent whose face was like that of a woman. Sculptors - Pedro Mira & Melineige Beauregard

his hands. Then they sat down to talk, and Hasib asked his mother about the woodcutters who had left him to die. "They came and told me that a wolf had eaten thee. As for them, they became wealthy merchants. But every day, they bring me meat and drink." Hasib said, "Tomorrow go to them and say, "My son Hasib Karim al-Din hath returned from his travels, so come to meet him and salute him." She delivered her son's message, and they changed color when they heard. The woodcutters called together several merchants and, acquainting them with all that had passed between themselves and Hasib took counsel with them. The merchants said they should give him half their wealth." They agreed, and the next day, each of them took half his wealth and laid it before Hasib saying, "This is thy bounty, and we are in thy hands." He accepted their peace offering and

said, "What is past is past." They returned, "Come, let us walk about, take our solace in the city, and visit the Hammam." "No! I have taken an oath never again to enter the baths so long as I live."

Hasib became master of money and one of the chiefs of the guild. He lived like this awhile. One day, as he passed the door of a Hammam, the bath man caught his eye and ran up to him saying, "Favor me by entering the bath that I may show thee hospitality." Hasib refused, alleging that he had taken a solemn oath never again to enter the Hammam, but the bath man was instant. Then all the bath servants set upon Hasib, dragging him in and pulling off his clothes. But hardly had he sat down against the wall when a score of men accosted him, saying, "Rise and come with us to the Sultan, for thou art his debtor." They mounted Hasib on a horse and returned with him to the sultan's palace. After they had eaten and washed their hands, the Vizier said to him, "The sultan is

"After this, take up my flesh and, laying it on a brazen platter, carry it to the King and give it to him to eat. When he has eaten it, and it has settled in his stomach, and wait by him. When he has digested the meat, give him some wine to drink, and he will be healed." Sculptor - Melineige Beauregard

nigh upon death by leprosy, and the books tell us that his life is in thy hands. Accompanied by a host of Grandees, he took him to the king's chamber. They found the king lying on his bed, his face shrouded in cloth and groaning from pain. Vizier Shamhur stood up (while all present also stood) and, approaching Hasib said, "We are all thy servants and will give thee whatsoever thou asks, but cure the King." Hasib, uncovering the king's face, saw that he was at the last fatal stage of the disease. "True that I am the son of Allah's prophet, Daniel, but I know nothing of his art. They put me for thirty days in the school of medicine, and I learned nothing of the craft. How can I make him whole, seeing I know neither his case nor its cure?" The Vizier rejoined, "The remedy of his sickness is the Queen of the Serpents, and thou know her hiding place and have been with her." When Hasib

heard this, he knew it came of his entering the baths and repented, "What is the Queen of the Serpents? I know her not." Retorted the Vizier, "Deny not the knowledge of her!" Shamhur opened a book and read, "The Queen of the Serpents shall forgather with a man who shall abide with her two years; then shall he return from her and come forth, and when he enters the Hammam bath, his belly will become black." Then said, "Look at thy belly." So Hasib looked down at his belly, and it was black." I had stationed three men at the door of every Hammam, bidding them to let me know when they found one whose belly was black." Then all the other Viziers, Emirs, and Grandees flocked about Hasib, and he cried out, "I never saw nor heard of the matter!"

The Grand Vizier called the hangman and commanded him to strip Hasib and beat him "wilt thou persist in denial? Show us where thou came out, and no harm shall befall thee." Hasib eventually yielded and said, "I will show you the place." They came to the mountain containing the cavern wherein he had found the cistern full of honey. They all dismounted and followed him as he entered. He showed them the well, at which point the Vizier sat down and, sprinkling perfumes upon a chafing dish, began to mutter charms, for he was a magician and skilled in spiritual arts. He cried out and said, "Come forth, Queen of the Serpents!" The water of the well sank, and a great door opened from which came a mighty and thunderous cry. A serpent emerged as big as an elephant, casting out sparks, like red hot coals, from its eyes and mouth. On its back was a charger of red gold, set with pearls and jewels, holding a serpent from whose body issued such splendor that the place was illuminated by it. Her face was fair and young, and she spoke with the most eloquent tongue. The Serpent-Queen turned right and left till her eyes fell upon Hasib, "Where is the covenant thou made with me, and the oath thou swore to me? There is no fighting against fate. It is Allah's will that I be slain, and King Karazdan be healed of his malady." So she wept, and Hasib wept to see her weep. The abominable Vizier Shamhur put out his hand to grab hold of her, but she said to him, "Hold thy hand, or I will reduce thee to a heap of black ashes." Then she cried to Hasib, "Draw near me, for my death was foreordained to be at thy hand." He took her, and they set out on their return to the city.

On their journey, the Queen of the Serpents said to him privately, " Hasib, when thou come to the Vizier's house, he will bid thee behead me and cut me in three; but refuse saying, 'I know not how to slaughter' and leave him to do it with his hand. When he hath cut my throat and divided my body into three pieces, a messenger will come to bring him to the king. He will ask him to lay my flesh in a cauldron of brass and set it before the king and say, 'Keep up the fire under the cauldron till the scum rises, then skim it off and pour it into a vial to cool. Wait till it cools, and then drink it. When the second scum rises, skim it off and pour it into a vial for my return from the king, that I may drink it for an ailment I have.' Do what he says but when the first scum rises, set it in a vial and keep it close by but beware of drinking it, or no good will befall thee. When the second scum rises, skim it off, put it in a second vial, and drink it as soon as it cools. Thy heart will become the home of wisdom. When the Vizier returns and asks for the second vial, give him the first and note what shall befall him. After this, take up my flesh and, laying it on a brazen platter, carry it to the king and give it to him to eat. When he has eaten it, and it has

settled in his stomach, wait by him. When he has digested the meat, give him some wine to drink, and he will be healed."

They came to the Vizier's house, and he said to Hasib, "Come in!" He set down the platter, and the Vizier bade him slay the Queen of the Serpents, but he said, "I know not how to kill, do it with your own hand." So Shamhur took the Queen from the platter and slew her. He cut her in three and, laying the pieces in a brass cauldron, set it on fire and sat down to await the cooking of the flesh and the preparation of the vials. He gave Hasib two vials and bade him drink the first scum and keep the second for his return. Hasib did as the Queen told him and kept the first scum, setting it aside. The second scum rose, and he skimmed it off and put it in the other vial he kept hidden for himself. When the meat was done, he took the cauldron off the fire and sat awaiting the Vizier. On his return, the Vizier asked, "What hast thou done with the first vial?" "I drank its contents, but now I feel as if I were on fire." The villain Vizier made no reply hiding the truth but said, "Hand me the second vial." Hasib handed him the first vial, and the Vizier drank it. He had hardly finished drinking when the vial fell from his hand, and he dropped dead. Hasib drank off the contents of the first vial. No sooner had he done so than the highest waters of wisdom began to well up in his heart. He opened up to the fountains of knowledge, and joy and gladness overcame him. He raised his eyes and saw the seven heavens and all therein. He saw the revolution of the spheres, the planets, the scheme of their movements, and the fixed stars. He saw the contour of the land and sea, whereby he became informed about geometry, astrology and astronomy, and mathematics, and he understood the causes and consequences of eclipses of the sun and moon. Then he looked at the earth and saw all minerals and vegetables, and he learned their properties and virtues so that he became instantly versed in medicine, chemistry, natural magic, and the art of making gold and silver. He carried the flesh of the Queen of the Serpents till he came to the palace and went to King Karazdan. Kissing the ground before him, he told him of the Vizier's death. Hasib set the platter before the king and made him eat a slice of the flesh. He ate it all, and his skin began to shrink and scale off. He perspired, so the sweat ran from his head to his heels. Then he became whole, and no trace of the disease remained. Hasib carried him to the bath, washed his body, and he was restored to health. The king donned his richest robes and, sitting on his throne, asked Hasib to sit beside him. All his Viziers, Emirs, Captains, and the Grandees of his realm came to him and expressed joy at his recovery. The king said to the assembly, "This is Hasib Karim al-Din, who hath healed me of my sickness. I make him my Chief Vizier in the stead of the Vizier Shamhur." "Hearkening and obedience," they answered, and all flocked to kiss Hasib's hand.

Hasib, from a docile know-nothing, unskilled in reading and writing, became adept in every science and versed in all manner of knowledge so that the fame of his learning spread abroad. He became renowned for his skill in medicine, astronomy, geometry, astrology, alchemy, and magic. One day, he asked his mother, "My father Daniel was exceedingly wise and learned. Tell me what he left by way of books!" His mother brought him the chest and, taking out the five pages which were saved when the library was lost, gave them to him, saying, "These five scrolls are all thy father left thee." So he read them

He saw the revolution of the spheres, the planets, the scheme of their movements, and the fixed stars. He saw the contour of the land and sea, whereby he became informed about geometry, astrology and astronomy, and mathematics. Sculptor - Pedro Mira

and said to her, "O my mother, these leaves are only part of a book: where is the rest?" "Thy father made a voyage taking with him all his library and, when he was shipwrecked, every book was lost save only these five leaves. When he returned, he found me with child and said to me: 'Thou wilt bear a boy; so take these scrolls and when thy son shall grow up and ask what his father left him, give these pages to him and say, 'Thy father left these as your only inheritance. When you have read and understood them, you will be the most learned man of your time.' Hasib, now the most learned of his age, lived in pleasure, solace, and delight of life till the destroyer of delights and the severer of societies came to him.

ARABIAN NIGHTS — SCULPTURE PARK MAP

Part II

The Fisherman and the Genie

There was an old fisherman that was so poor he could hardly earn enough to provide for himself, his wife, and three children. He went every morning to fish and cast his nets. One morning as he drew his nets toward the shore, he found them very heavy and thought he had a good catch. Instead, he found nothing but the carcass of a donkey. He cast his nets the second time but brought up a basket full of gravel and slime. Full of despair, he cast the nets the third time and up came nothing but stones, shells, and mud. When daylight appeared, he said his prayers and cast his nets for the fourth time. When he drew them in with great difficulty, he found a vessel of yellow copper instead of fish. He observed that it was shut and sealed with lead. He examined the vessel and shook it but heard nothing. He took a knife, broke the seal, and opened it. Out came very thick smoke that knocked him back three paces. The smoke ascended to the clouds and extended along the sea and shore. When the smoke was all out of the vessel, it reunited itself and became a solid body that formed a genie twice as high as the greatest of giants.

The fisherman would have fled, but he was so frightened that he could not move. "Solomon!" Cried the genie immediately, " Solomon, the great prophet, pardon, pardon! I will never more oppose your will! I will obey all your commands." When he heard these words, the fisherman recovered his courage and said, "It is over eighteen hundred years since the prophet Solomon died, and we are now at the end of time. Tell me how you came to be shut up in this vessel." Turning to the fisherman with a fierce look, the genie said, "You must speak to me with more civility!" "For releasing me, I have only one favor to grant you. To give you the choice in what manner you would have me take your life." "Is that your reward for the good services I have done you?" Replied the fisherman. "I cannot treat you otherwise." Said the genie. "Hearken to my story."

He took a knife, broke the seal, and opened it. Out came very thick smoke that knocked him back three paces.

"For releasing me, I have only one favor to grant you. To give you the choice in what manner you would have me take your life!"

"I am one of those rebellious spirits that opposed Solomon, the great prophet. The great monarch sent Asaph, his chief minister, to apprehend me. Asaph forced me before his master's throne. Solomon, the son of David, commanded me to submit myself to his command. I rebelled and refused to obey. He imprisoned me in this copper vessel to punish me and threw me into the sea. During the first hundred years of imprisonment, I swore that if anyone delivered me, I would make him rich beyond his dreams, but that century ran out, and nothing happened. During the second, I swore to open all the treasures of the earth to anyone that should set me free, but with no better success. In the third, I promised to grant my deliverer three requests every day, but this century ran out. Being angry at finding myself a prisoner for so long, I swore that if anyone

should deliver me, I would kill him without mercy and grant him no other favor but choose how they would die. Since you have delivered me today, I give you that choice."

The fisherman was mortified, but he quickly thought of a strategy. "Before I choose the manner of my death, Answer me one question." The genie replied, " Ask what you will, but make haste." The fisherman asked, "This vessel is not capable of holding one of your size. How is it possible that your whole body could fit in it?" The genie replied, "I declare that I was there just as you see me here. Do you not believe me?" "No," said the fisherman, "nor will I believe you unless you show me." Upon this, the body of the genie dissolved into smoke, reentered the vessel, and a voice came forth, which said, "I am all in the vessel, do you believe me now?" Instead of answering the genie, the fisherman took the cover of lead and speedily shut the vessel. "Now it is your turn to beg my favor. I should throw you back into the sea, then build a house upon the bank, where I will dwell and tell all fishermen to beware of a wicked genie." "Fisherman," said the genie in a pleasant tone, "Do not do what you say, for what I spoke before was only by way of jest." "It is in vain

Upon this, the body of the genie dissolved into smoke, reentered the vessel, and a voice came forth, which said, "I am all in the vessel, do you believe me now?" Sculptors - Wilfred and Edith Stijger

you talk of me letting you out. I am going to throw you to the bottom of the sea." Said the fisherman. "I promise to do you no harm. I will show you how to become exceedingly rich." Cried the genie. The hope of delivering his family from poverty prevailed with the fisherman, and he eventually took off the covering of the vessel. At that very instant, the smoke came out and the genie kicked the vessel into the sea. This action frightened the fisherman. The genie laughed at the fisherman's fear and said, "Take your nets and follow me." The fisherman took up his nets and followed, but with some distrust. They passed by the town and came to the top of a mountain; they descended into a vast plain and a great pond between four hills. When they went to the side of the pond, the genie said, "Cast in your nets here." The fisherman saw many fish and was surprised they were of four colors—white, red, blue, and yellow. He threw in his nets and brought out one of each color, and judging that he might get a considerable sum for them, he was joyful. "Present those fish to your sultan, and he will give you more money for them than you ever had in your life. You may come every day to fish in this pond, but I warn you, do not throw in your nets more than once a day. Follow my advice, and you will prosper." Having spoken thus, he struck his foot upon the ground, which opened up and swallowed him.

"Under my enchantments, I command thee to become half marble and half man." Immediately, I became such as you see me now, a dead man among the living and a living man among the dead. Sculptor - Katsuhiko Chaen

Part 2 - The Tale of the Ensorcelled Prince

The fisherman went straight to the sultan's palace to present his fish. The sultan was surprised when he saw the four colored fishes and said to his first vizier, "Take those fish to the cook! I feel sure they must be as good to eat as they are to look at." The Sultan ordered the vizier to give the fisherman four hundred pieces of gold. The vizier carried the fish to the cook and said, "There are four fishes newly brought to the sultan. He orders you to prepare them." She put the fish over the fire in a frying pan when suddenly the kitchen walls opened, and in came a young lady of remarkable beauty clad in flowered satin, bracelets of gold, and carrying a rod of myrtle in her hand. She went toward the frying pan and, touching one of the fishes with the end of the rod, said, " Fish, fish, art thou in thy duty? " And then the four fish lifted their heads and said, " Yes, yes; if you pay your debts, we pay ours. If you fly, we overcome and are content." As soon as they had uttered these words, the lady overturned the frying pan, dumped the fish, and entered the wall, which shut and became as it was before.

The cook gathered up the fish but found them blacker than coal. In came the vizier and asked her if the fishes were ready. She told him all that had happened, so he sent for the fisherman to bring four more such fish. The fisherman went away and, coming to the pond, threw in his nets, took four such fishes as before, and brought them to the vizier. The minister took them himself and shut himself up alone with the cook. She put them over the fire, and the kitchen wall opened. The same lady came in with the rod in her hand, touched one of the fishes, and spoke to it as before. Once again, all four gave her the same answer.

Afterward, the apparition overturned the frying pan and retired to the same place in the wall where she had come from. "This is too extraordinary to be concealed from the sultan." The vizier said. He explained the marvels to the Sultan, who was impatient to see these events for himself. He sent for the fisherman and commanded him to bring four more such fish. The fisherman went to the pond the next morning, caught four more fish, and brought them to the sultan, who gave him another four hundred pieces of gold. As soon as the sultan had the fish, he ordered them to be carried into the kitchen with everything necessary to fry them. He shut himself up there with the vizier, who put them in the pan over the fire when the kitchen wall opened. The same events happened as the days before. The Sultan, who was a brave man, resolved to investigate what it all meant. He got the directions to the place from the fisherman, readied himself with a scimitar, and set forth alone upon the adventure.

When the Sultan came to the plain, he walked on till the sun rose and saw a great building. He found a magnificent palace of fine black polished marble covered with fine steel, as smooth as a looking glass. The gate had two doors, one of them open. He entered and called out, "Is there nobody here to receive a stranger who comes in for some refreshment as he passes by?" Nobody answered. The silence increased his astonishment as he entered a spacious court and looked on every side to see if he could see anybody, but he saw no living thing. The sultan entered the great halls and came into a magnificent court, in the middle of which was a grand fountain, where water issued from the mouths of four lions, and

"There are four fishes newly brought to the sultan. He orders you to prepare them." She put the fish over the fire in a frying pan when suddenly the kitchen walls opened. Sculptor - JOOheng Tan

this water, as it fell, formed diamonds and pearls. A garden surrounded the castle with flowerpots, fountains, groves, and a thousand other fine things, and to complete the beauty of the place, an infinite number of birds filled the air with their melodious songs. Suddenly, he heard lamentable cries. "Forbear to persecute me and by a speedy death put an end to my sorrows. Alas! Is it possible that I am still alive after so many torments as I have suffered?' The sultan made his way toward the voice. He came to the gate of a great hall, opened it, and saw a handsome young man, richly dressed, seated upon a throne raised a little above the ground. The sultan drew near and saluted him. The young man returned his salute and said, My lord, I should rise to receive you, but I am hindered from doing so by an unfortunate reason. At these words, he lifted his gown and showed the sultan that he was a man only from the head to the waist and that the other half of his body was black

marble. The Sultan said, "I am impatient to hear your history. I beg you to tell me." The young man began his story.

My father Mahmoud was king of the Black Isles, which takes its name from the four mountains, for those mountains were formerly islands. The capital was where that pond now is. My father died, and I married soon after succeeding him. After five years of marriage, my wife, the queen, took no more delight in me. One day, I lay down on a sofa. Two of her ladies came and sat down. They thought I was fast asleep and spoke very low. "Is the queen wrong not to love such an amiable prince?" "Certainly," replied the other. "I do not understand how he does not see it?" "How would you have him see it? She mixes an herb in his drink every evening, which makes him sleep so soundly that she has time to go where she pleases." I pretended to awake without hearing what they spoke of. The queen returned and presented me with a cup full of such water, but instead of drinking it, I threw out the water so that she did not notice. Believing I was asleep, she got up and said, "Sleep, and never wake again!"

68

She begged me to build a burying place for herself, where she would remain to the end of her days. I agreed and made a stately palace. She called it the Palace of Tears.

As soon as my wife went out, I took my scimitar and followed her. She entered a garden, and I saw her meet an Indian man, and I could see that they were lovers. They passed before me. I had already drawn my scimitar, so I struck him hard on the neck when he passed me. I thought I had killed him and escaped without making myself known to the queen. The blow I gave was mortal, but she preserved his life by the force of her enchantments. He was in a state of being neither dead nor alive. When I returned home and awoke the next morning, I found the queen clad in mourning, her hair hanging about her eyes. She said, "I have received news of the death of my dear mother, father, and brother." I acted along with her lies. She retired to her apartment and gave herself up to sorrow, spending a whole year in mourning. She begged me to build a burying place for herself, where she would remain to the end of her days. I agreed and made a stately palace. She called it the Palace of Tears. She snuck her undead lover inside, yet with all her enchantments, she could not cure the wretch. Every day she visited, but I pretended to know nothing of it. She continued for two whole years.

Exasperated, I went to the Palace of Tears, hid, and heard her speak, "It is now three years since you spoke one word to me. Is it from insensibility or contempt?" I was so enraged that this creature was doted upon and adored that I appeared suddenly and, addressing the tomb in my turn, cried, "O tomb! Why dost thou not swallow up this pair of monsters?" The queen rose like a fury. "Cruel man! Thou art the cause of my grief. It is thy barbarous hand which brought him into this lamentable condition, and thou art so hard-hearted as to come and insult me. "Yes, " I said, in a rage, "it was I, and I ought to have treated thee in the same manner." I drew out my scimitar, but she pronounced words I did not understand and added, "Under my enchantments, I command thee to become half marble and half man." Immediately, I became such as you see me now, a dead man among the living and a living man

among the dead. She brought me into this hall and, by another enchantment, destroyed my capital, reducing it to the pond and desert field. The fishes of four colors in the pond are the people of four different religions who inhabited the place. Her revenge was not satisfied, so she comes every day and gives me a hundred blows with an ox goad, and when she is done, she covers me with this robe of brocade that you see.

The sultan resolved to help the young king. The next morning, he got up before dawn and went to the Palace of Tears. He found it lit up with an infinite number of candles. He drew his scimitar and killed the wretch without resistance. He then dragged his corpse into the court and threw it into a well. After this, he lay down in the wretch's bed, took his scimitar under the blanket, and waited there to execute his plan. After the enchantress had given her husband a hundred blows, she went to the Palace of Tears and, approaching the bed where she thought the Indian was, cried, "My sun, my life, will you always be silent? Are you resolved to let me die without giving me one word of comfort?" The Sultan, as if he had woken out of a deep sleep, answered the queen in a grave tone, "There is no strength or power but in God alone." At these words, the enchantress shouted, "My dear lord, is it certain that I hear you speak to me?" "Unhappy wretch," said the sultan, "Art thou worthy that I answer thee? Why do you reproach me thus?" Replied the queen. "The cries." Replied he. "The groans and tears of thy husband, whom thou treat with so much indignity and barbarity, hinder me from sleeping night and day. I should have been cured long ago had thou disenchanted him. That is the cause of the silence which you complain of." "Very well," said the enchantress, "to pacify you, I will restore him as he was!" The enchantress went immediately to her husband and restored him to his former condition. Then the enchantress said to him, "Go from this castle and never return here on pain of death!" The young king happily obliged.

The enchantress returned to the Palace of Tears and said, "Dearest, I have done what you ordered." The sultan in disguise replied, "That is not sufficient for my cure. The town, and its inhabitants, and the four islands, which thou hast destroyed by thy enchantments, must be restored." The enchantress, filled with hope from these words, used her enchantments to restore the city. The fish became men, women, and children. Muslims, Christians, Persians, or Jews, as they were before. The houses and shops were filled with their inhabitants. All things were as they were before the enchantment.

The enchantress returned to the Palace of Tears. "My dear," She cried as she entered, "I come to rejoice with you for the return of your health. I have done all that you required of me." "Come near," said the sultan. She obeyed. He rose and, with a blow of his scimitar, cut her in two so that one half fell one way and the other another. Then, he went to look for the young king. "King," said he, embracing him, "Your cruel enemy is dead. You are henceforward welcome in my capital as an honored guest." "You are my deliverer," replied the young king. "I will accompany you and leave my kingdom without regret." "Since you will do me the honor to accompany me, and as I have no child, I appoint you my heir and successor."

As for the fisherman, since he was the first cause of the deliverance of the young prince, the sultan gave him a great fortune, which made him and his family wealthy for the rest of their days.

The Three Princes and the Princess Nouronniha

There was once a sultan of India who had three sons: Houssain, Ali, and Ahmed. With princess Nouronnihar, his niece, they were the ornaments of his court. The sultan's Brother died young, so the Sultan brought her up with the three princes. Her singular beauty and personal accomplishments distinguished her among all the princesses of her time. All three brothers wanted to marry the princess, so the Sultan promised marriage to the one that brought him the most extraordinary curiosity. After they wished each other success, they mounted their horses, and each took a different road.

All three brothers wanted to marry the princess, so the Sultan promised marriage to the one that brought him the most extraordinary curiosity. Sculptors - Wilfred & Edith Stijger

Prince Houssain set his course toward India. He traveled over deserts and barren mountains through populous and fertile countries until he arrived at Bisnagar. There he found a multitude of shops stocked with the finest linens, silks, and brocades from India, Persia, China, and other places. There was porcelain from Japan and China, carpets of all sizes, goldsmiths, jewelers, and flowers. He could not believe his eyes and was amazed to see so many riches in one place. Houssain saw a crier pass by with a piece of carpet on his arm, about six feet square, and cry it at thirty purses. The prince called to the crier and asked to see the carpet, which seemed to be valued at an exorbitant price for its size. "Certainly," said Prince Houssain, "it must have something very extraordinary about it?" "You have guessed right, sir," replied the crier, "Whoever sits on this piece of carpet may be transported wherever he desires to go without being stopped by any obstacle." After some negotiations, Prince Houssain became the possessor of the carpet, which he never doubted would gain him the hand of the Princess.

Prince Ali, the second brother, traveled into Persia with a caravan and, after four months of traveling, arrived at Schiraz. Having made friends on the way with some merchants, he passed for a jeweler and lodged in the same khan with them. Prince Ali entered the quarter where they sold precious stones, gold and silver work, brocades, silks, fine linens, and other choice merchandise. Among all the criers who passed with several things to sell, he saw one who held an ivory tube about a foot in length and cried it at thirty purses. At first, he thought the crier was mad and confronted him. The crier said, "Sir, you

"This tube is furnished with a glass at both ends. By looking through one of them you see whatever object you wish to behold."

are not the only person that takes me for a madman on account of this tube. You shall judge yourself whether I am or not. Observe that this tube is furnished with glass at both ends. By looking through one of them, you see whatever object you wish to behold." Ali looked through, wishing simultaneously to see the sultan, his father. He immediately beheld him in perfect health, sitting on his throne. Prince Ali needed no other proof, and after negotiations, he purchased the tube. Prince Ali was confident that his brothers would not be able to meet with anything so rare and marvelous. Princess Nouronnihar would surely be his wife.

Prince Ahmed took the road to Samarcand, and the day after his arrival, he had not walked long before he heard a crier, who had an artificial apple in his hand, cry out five-and-thirty purses. He stopped the crier and said, "Let me see that apple, and tell me what virtue or extraordinary

"We shall transport ourselves instantly into her room by my carpet." As soon as the order was given, all three sat down on the carpet and framed the same wish and were transported into Princess Nouronnihar's chamber.
Sculptors - Wilfred & Edith Stijger

property has it valued at so high a price." "Sir," said the crier, putting it into his hand, "This apple looks very ordinary, but it cures all sick persons of the most fatal diseases. If the patient is dying, it will immediately restore him to perfect health. This is done by the patient smelling the apple."

After a demonstration and some negotiations, Prince Ahmed purchased the apple and was sure it would gain him the princess's hand in marriage.

Prince Ahmed returned to the Indies and arrived at the inn where the Princes Houssain and Ali were waiting for him. Prince Houssain said, "Brothers, we shall have time enough later to entertain ourselves with the particulars of our

Her singular beauty and personal accomplishments distinguished her among all the princesses of her time.

travels. Let us not conceal the curiosities we have brought home but show them. I will tell you that the carpet on which I sit looks ordinary, but whoever sits on it and desires to be taken to any place is immediately carried thither." Prince Ali said, "Brother, your carpet is one of the most surprising things imaginable. But you must allow that there may be other things at least as wonderful. To convince you, here is an ivory tube, which appears to be no more a rarity than your carpet. But by looking at one end, you see whatever you wish to behold. Take it," added Prince Ali, presenting the tube to him. Prince Houssain took it, clapped the end to his eye, and wished to see Princess Nouronnihar. Prince Ali and Prince Ahmed were surprised to see his mood change suddenly to tremendous pain and grief. Prince Houssain cried out, "Alas! In a few moments, our lovely princess will breathe her last! I saw her in her bed, surrounded by attendants, who were all in tears." Prince Ahmed said, "Provided we make haste and lose no time, we may preserve her life." Then he took out the artificial apple and, showing it to his brothers, said, "this apple which you see here cost as much as the carpet or tube. If a sick person smells it, it immediately restores them to perfect health." "If that is true," replied Prince Houssain, "we shall transport ourselves instantly into her room by my carpet. As soon as the order was given, all three sat down on the carpet and framed the same wish, and were transported into Princess Nouronnihar's chamber.

Prince Ahmed no sooner saw himself in Nouronnihar's room than he rose off the tapestry, went to the bedside, and put the apple under her nose. The princess opened her eyes and turned her head from one side to another, looking at the persons who stood about her. She then stood up and was healthy again. The Sultan embraced the princes with the greatest joy, both for their return and the recovery of the princess. Each prince presented the curiosity he had brought. Prince Houssain, his carpet, Prince Ali, his ivory tube, and Prince Ahmed, the artificial apple. They begged the Sultan to declare which of them he would give Princess Nouronnihar for a wife. The Sultan remained silent for some time until, at last, he said to them, "I would declare one of you if I could do so with justice. Prince Ahmed, the princess is obliged to your artificial apple for her cure. But, could you have been so serviceable to her if you had not known by Prince Ali's tube the danger she was in? And if Prince Houssain's carpet had not brought you to her so soon?" Therefore, as neither the carpet, the ivory tube, nor the artificial apple has any preference over the other, I cannot grant the princess to any one of you. The only fruit you have reaped from your travels is the glory of saving Princess Nouronnihar's life and restoring her to health.

"Brother, your carpet is one of the most surprising things imaginable. But you must allow that there may be other things at least as wonderful."

Part 2 - Prince Ahmed and The Fairy Banou

Prince Ahmed lost an archery contest against his brothers Prince Houssain and Prince Ali. The winner of which would marry princess Nouronnihar. To soothe his sorrow, he explored the countryside looking for the arrow he had shot and lost. Ahmed found his arrow in an area of craggy rocks and a cluster of caves. He entered one of the cavities and cast his eyes on an iron door. Pushing it open, he discovered an easy descent and walked down into a spacious square. At that moment, a lady of majestic beauty adorned in rich clothes and jewels appeared. Raising her voice, she said, "Come near, Prince Ahmed." He could not comprehend how he could be known to this lady. He returned the lady's salutation, "I return you a thousand thanks for welcoming me to this place, but without being guilty of rudeness, may I ask how you know me?" The lady said, "You cannot be ignorant that genies, as well as men, inhabit the world. I am the daughter of one of the most powerful and distinguished of these genies, and my name is Pari Banou. I know you, the Sultan, your brothers, and Princess Nouronnihar. I am no stranger to your love or your travels. In fact, I exposed for sale the artificial apple you bought at Samarcand, the carpet Prince Houssain met with at Bisnagar, and the tube Prince Ali brought from Schiraz. You seemed to me worthy of a better fortune than marrying Princess Nouronnihar. I was present when you drew your arrow and foresaw it would not go beyond Prince Houssain's. I took it in the air and made it strike against the rocks near which you found it. I would admit you into my court as my husband, pledging your faith to me. "You are my husband, and I am your wife."

The days following the wedding were a continual feast of new dishes, concerts, dances, shows, and diversions. At the end of six months, Prince Ahmed, who always loved and honored his father, wanted to know how he was. He mentioned it to the fairy and said that she should give him leave. This discourse alarmed the fairy and made her fear it was only an excuse to leave her. "Prince," she said, "I grant you leave to go on condition that your absence shall not be long." "Go when you please; do not tell the sultan of our marriage, what I am, or where you are settled. Beg him to be satisfied with knowing that you are happy."

Prince Ahmed took leave of the fairy, embraced her, and renewed his promise to return soon. When he arrived at his father's capital, the people received him with acclamations and followed him in crowds to the sultan's palace. The Sultan received him with great joy. Prince Ahmed begged his father to let him remain silent on where he was and be satisfied to know that he was happy and contented. After some time, Prince Ahmed requested that he leave. "Son, I cannot refuse you leave, but I would much rather you stay with me. At least tell me where you are going." "Sir, what your majesty asks is part of the mystery I spoke of. I beg you to leave me to remain silent on this." The Sultan pressed Prince Ahmed no more but said to him, "Son, I leave you at your liberty. You will always be welcome when you come." Prince Ahmed stayed three more days at his father's court and then returned to the fairy. She received him with great joy, as she did not expect him so soon. She was at greater ease with the prince leaving now, and from that point, Prince Ahmed constantly paid his father visits, always in richer

To soothe his sorrow, he explored the countryside looking for the arrow he had lost. Sculptors - Etual Ojeda & Sue McGrew

and more brilliant attire. Some viziers judged Prince Ahmed's grandeur and power and conspired to make the Sultan jealous of his son. They said it was common knowledge where the prince had retired and how he could afford to live so lavishly with no revenue or income. He seemed to come to court only to brave him, and he should fear the prince might stir up the people's favor and dethrone him.

The Sultan was far from thinking that Prince Ahmed could be capable of so wicked a design, but he resolved to have Prince Ahmed watched, unknown to his grand vizier. He sent for a sorceress. "My son Ahmed comes to my court every month, but I cannot learn from him where he resides. I believe you can satisfy my curiosity without letting him, or any of my court, know anything of the matter. Go immediately and bring me word." The sorceress left the sultan and, knowing where Prince Ahmed found his arrow, she hid near the rocks. The next morning Prince Ahmed went out as usual and passed by the sorceress. Seeing her lie with her head on the rock, complaining as if she were in great pain, he turned

"I rejoice with you and approve of your marrying a fairy so rich and powerful." Sculptors - Johannes Hogebrink & Rogelio Evangelista

his horse and asked her what the matter was. The sorceress answered that she was going to the city but was taken with so violent a fever that her strength had failed her. "Good woman," replied Prince Ahmed, "you are not so far from help as you imagine. I can assist you." The sorceress made many affected efforts to get up, pretending that her illness prevented her. Two of the prince's attendants helped her and followed the prince, who turned back and sent for the fairy. When the fairy Pari Banou came, he said, "My princess, I desire you would have compassion on this good woman as I promised her assistance." Pointing to the sorceress. The fairy Pari Banou, who had her eyes fixed upon the pretend sick woman, ordered two women to take her into the palace. She then went to Prince Ahmed and whispered in his ear,

"Prince, I commend your compassion, but I am afraid this woman is not so ill as she pretends to be. She was sent to cause you great trouble. I will deliver you out of all the snares that may be laid for you." The two women, who were fairies as well, set the sorceress up with a comfortable resting place and brought her a drink. "Drink this. It is the water of the fountain of lions and a remedy against all fevers." She cried out, "Oh, the admirable potion! Being cured by a miracle, I would rather not lose time but continue my journey." Pari Banou said, "Good woman, I will not detain you." The sorceress prostrated herself with her head on the carpet and then took her leave.

The sorceress returned to the capital and told the Sultan everything that happened from beginning to end. Then she said, "What does your

majesty think of these unheard-of riches of the fairy? Perhaps you will say you rejoice at the good fortune of Prince Ahmed, your son? Sir, I think otherwise. I believe Prince Ahmed is incapable of undertaking anything against your majesty, but who can say that the fairy may not inspire him with a design of dethroning your majesty? You ought to consider this of the utmost importance." The Sultan was sure that Prince Ahmed's natural disposition was good, yet he could not help being uneasy at the remarks of the old sorceress. He acquainted his Viziers with what he had learned and why he feared the fairy's influence over the prince and asked them for their advice. The sorceress disagreed with them and said, "If his majesty has any confidence in my advice, he will appeal to Prince Ahmed's honor and engage him through the fairy to procure certain advantages. Ask him many difficult demands so that he may sink under the impossibility of executing them. In time, he will be ashamed to appear and be forced to spend the rest of his life with his fairy. Then your majesty will have nothing to fear." When the sorceress finished her speech, the sultan asked his viziers if they had anything better to propose. Finding them all silent, he determined to follow the sorceress's advice.

The next day, when the prince came into his father's presence, the sultan said, "Son, you made the place you retreat to a mystery to me. I know not what reason you have but I know your good fortune. I rejoice with you and approve of your marrying a fairy so rich and powerful. I couldn't procure such a great match for you. I have a request now that you have risen to a high rank. Procure from her a pavilion that might be carried in a man's hand yet which would extend over my whole army. All the world knows that fairies can do the most extraordinary things." Prince Ahmed doubted whether the power of genies and fairies extended so far as to furnish a tent such as his father desired. Moreover, he had never asked anything like it of the fairy Pari Banou. When he returned to the fairy, he said, "The Sultan has imposed upon me the task of worrying you. You know the care I have taken to conceal you from him, but he knows of you. My father asks for a pavilion large enough to shelter him, his court, and his army yet small enough for a man to carry it in his hand." "Prince," replied the fairy, smiling, "I shall always take great pleasure in whatever you desire me to do." Then the fairy sent for her treasurer, to whom she said, "bring me the largest pavilion in my treasury." She returned with a pavilion, which she held in her palm. Prince Ahmed took it, and the next day mounted his horse and went with the usual attendants to the sultan.

The sultan, convinced that such a tent was beyond all possibility, was surprised at the prince's diligence. He took the tent and admired its smallness. But when he had set it up in the great plain, he found it large enough to shelter an army twice as large as he could bring into the field. His amazement was so great that he could not recover himself. The Sultan expressed outward obligation to the prince. But within, he became more jealous, considering the prince might perform things infinitely above his power with the fairy's assistance. He went to consult the sorceress again, who advised him to request the prince to bring him some of the water of the fountain of lions. The sultan asked his son, "I am informed that the fairy uses a certain water, called the water of the fountain of lions, which cures all sorts of fevers. As I am sure my health is dear to you, I do not doubt

you will ask her for a bottle of that water for me." Prince Ahmed was thunderstruck at this new request. Still, Prince Ahmed returned to the fairy the next morning and related his father's latest proposal. The fairy Pari Banou replied, "Whatever advice the sorceress can give him, he shall find no fault with you or me. There is a great deal of wickedness in this demand. The fountain of lions is situated in the middle of a court of a great castle. The entrance is guarded by four fierce lions, two of which sleep while the other two are awake. But let that not frighten you. I will give you means to pass by them without any danger."

Pari Banou was hard at work with her needle, and as she had by her side several balls of thread. She took one up and, presenting it to Prince Ahmed, said, "First, take this ball of thread. Second, you must have two horses. One you will ride yourself, and the other you will lead loaded with a sheep cut into four quarters and killed today. Third, you must have a bottle for the water. Set out early tomorrow morning, and when you have passed the iron gate, throw before you the ball of thread, which will roll till it comes to the castle gates. When it stops, you will see the four lions as the gates will open. The two that are awake will roar and wake the other two. Be not frightened but throw each of them a quarter of the sheep, clap spurs to your horse and ride to the fountain. Fill your bottle, and then return with the same speed. The lions will be so busy eating that they will let you pass."

Prince Ahmed set out the next morning and followed her directions carefully. When he arrived at the castle gates, he distributed the quarters of the sheep among the four lions, passed through the midst of them hastily, and got to the fountain. He filled his bottle and returned safe and sound. A little distance from the castle gates, he turned around and saw two lions coming after him. He drew his saber and prepared for defense. Prince Ahmed saw one of them turn off the road, and he could tell he did not come to harm him by his head and tail. He put his sword into its sheath. They offered to go before him and the others to follow. He put his sword into its sheath. Guarded by the lions in this manner, he arrived at the capital. At the gates of the sultan's palace, the lions left and returned the way they came, though not without frightening all that saw them.

He approached the throne, laid the bottle at the sultan's feet, kissed the carpet, and said, "I have brought you the health-giving water which your majesty desired to keep in your treasury, but at the same time wish you may never have occasion to make use of it." The sultan showed joy outwardly but secretly became more and more jealous. He retired into an inner apartment and sent for the sorceress again. After conferring with her, he said to the prince the next day, "Son, I have one more ask of you, after which I shall expect nothing more from your influence with your wife. This request is to bring me a man a foot and a half high, whose beard is thirty feet long, and who carries upon his shoulders a bar of iron of five hundredweight, which he uses as a quarterstaff." Prince Ahmed did not believe there was such a man in the world as his father described, but the sultan persisted and told him that the fairy could do more incredible things.

The next day the prince returned to the underground kingdom of Pari Banou, to whom he told his father's new demand, "How can he suppose I should get hold of a man so small, armed as he describes? What arms could I make use of to reduce him to submission?" "Do not

The fountain of lions is situated in the middle of a court of a great castle. The entrance is guarded by four fierce lions, two of which sleep while the other two are awake. Sculptor- Etual Ojeda & Sue McGrew

worry yourself, prince," replied the fairy; "there is no danger in finding this man. It is my brother, Schaibar, who is so violent that nothing can prevent his giving gory marks of his resentment for any slight offense. Yet, on the other hand, he is so good as to oblige anyone in whatever they desire. He is made exactly as your father described him, and he has no other weapons than a bar of iron five hundred pounds in weight. I will send for him, and prepare not to be frightened when you see him."

The Fairy ordered a gold dish to be set with a fire in it under the porch of her palace, with a box of the same metal. Taking some incense out of this and throwing it into the fire, a thick cloud of smoke arose. Schaibar, who was but a foot and a half high, appeared gravely with his heavy bar on his shoulder, his beard, thirty feet long, supported itself before him, and a pair of thick mustaches were tucked up to his ears, almost covering his face. His eyes were tiny, like a pig's, and sunk deep in his head, which was enormous, and on which he wore a pointed cap. If Prince Ahmed had not known that Schaibar was Pari Banou's brother, he would not have been able to look at him without fear. Schaibar looked at the prince with an eye that might have chilled his soul and asked Pari Banou who this man was. She

The Sultan clapped his hands over his eyes in terror. This uncivil and rude reception so provoked Schaibar that he instantly lifted up his iron bar and killed him before Prince Ahmed could intercede. Sculptors - Johannes Hogebrink & Rogelio Evangelista

replied, "He is my husband. His name is Prince Ahmed, son to the Sultan of the Indies. I have taken the liberty to send for you on his account." At these words, Schaibar, looked at Prince Ahmed with a favorable eye and said, "If there is anything in which I can serve him, he has only to speak." "His father is curious to see you, and I desire he may be your guide to the Sultan's court." "He needs but lead the way," replied Schaibar.

The following day Schaibar set out with Prince Ahmed. When they arrived at the capital gates, the people saw Schaibar and ran to hide in their shops and houses. They found all the streets and squares deserted until they came to the palace, where the porters also ran away. The prince advanced without any obstacle to the council hall, where the Sultan was seated on his throne, giving audience. At the approach of Schaibar the officers abandoned their posts. Schaibar, carrying his head erect, went fiercely up to the throne without waiting to be introduced and accosted the Sultan of the Indies in these words, "You have asked for me, and here I am. What do you want with me?" Instead of answering, the Sultan clapped his hands over his eyes in terror. This uncivil and rude reception so provoked

Schaibar that he instantly lifted up his iron bar and killed the sultan before Prince Ahmed could intercede. All he could do was prevent Schaibar from killing the grand vizier, who sat on his right hand.

"These are those who gave him bad advice," said Schaibar as he killed all the other viziers on the right and left, flatterers and favorites of the sultan, who were Prince Ahmed's enemies. None escaped, but those who saved themselves by flight. When this execution was over, Schaibar went into the courtyard with the iron bar on his shoulder and, looking at the grand vizier, said, "I know there is a certain sorceress who is a greater enemy of the prince. Have her brought to me at once." The grand vizier immediately sent for her, and as soon as she arrived, Schaibar knocked her down with his iron bar, "Take the reward of thy pernicious counsel!" And left her dead on the spot. After this, he said, "I will treat the whole city in the same manner if they do not immediately acknowledge Prince Ahmed as their sultan and the sultan of the Indies." All that were present repeated acclamations of "Long life to Sultan Ahmed!" Immediately afterward, he was proclaimed throughout the whole town. Schaibar clothed him in the royal vestments, installed him on the throne, summoned his sister, Pari Banou, and made her the Sultaness of the Indies.

Kamar and Budur

There was once a king who had four wives but only one son. When his son, Kamar al-Zaman, turned 15, he wanted him to marry, but he refused. The Vizier advised the king to ask again in public when all the captains and emirs were present, he wouldn't dare say no in front of them, but he did. For this, the king locked him in an old tower. The Vizier advised the king to wait for fifteen days. In his tower prison, he was visited by an Ifrit known as Maymunah, daughter of the King of the Jinn. She fell in love with him because of his beauty. When she kissed Kamar, she heard the Ifrit Dahnesh enter. She asked him what his business was. He said he came from the realm of King Ghayur in China, where he beheld the king's beautiful daughter, who also refused to marry. Enraged by her obstinate behavior, her father locked her in a remote palace. Dahnesh fell in love with her and said she was the most beautiful human in the world. Maymunah challenged this, and to judge, they fetched the sleeping princess Budur and placed her at prince Kamar's side. They transformed into fleas and alternated waking one up while the other slept. The young man and the woman immediately fell in love with each other and exchanged rings. When both were asleep again, Princess Budur was brought back to her home. When the two awoke the following morning, they wondered what had happened and where their beloved had gone. As their people did not understand the reason for their claims and strange behavior, both were declared insane and kept in confinement.

Budur's stepbrother, Marzawan, heard

To judge, they fetched the sleeping princess Budur and placed her at prince Kamar's side. They transformed into fleas and alternated waking one up while the other slept. The young man and the woman immediately fell in love. Sculptors - Arianne van Rosmalen & Pedro Mira

her story, and he set out to search for her lover. During his adventure, he was shipwrecked and ended up floating toward the palace of Kamar. He was rescued from the water by the Vizier. When Marzawan met the prince, he told him about Budur, and the Prince brightened up. Kamar planned with Marzawan to go to Budur but told his father he would be away for only one night. Marzawan left camel bones and skin with blood to make Kamar's father think his son was dead to stop him from following them.

When they arrived at King Ghayur's Islands, Marzawan told Kamar he had to disguise himself as an astrologer. King Ghayur heard of him and requested he come to his castle and cure his daughter. Kamar then sent a letter to Princess Budur with her ring. She recognized the ring as the one she had exchanged with her lover and freed herself from her chains by force. All was revealed, and the king rejoiced in her sanity and married them. After Kamar and Budur married, Kamar desired to return to his father. The King consented, but only if they returned once a year. On their voyage, Kamar undressed Budur while she slept. He discovered a jewel that fastened her trousers. He took the jewel and went outside to have a better look. A giant bird swooped down and stole it and him as he held it up to the sky. He was carried away by the bird until he escaped and got lost. Eventually, he arrived at a city where he couldn't find anybody except a gardener.

With her husband gone from the boat, Budur dressed like him to prevent his men from going after her. When she arrived at the City of Ebony, she met King Armanus, who wanted his daughter to marry Kamar (Budur in disguise). To

An Ifrit is a class of Genie or Jinn. An enormous winged creature of fire, either male or female, who lives underground and frequents ruins. Ifrits live in a society structured along ancient Arab tribal lines, complete with kings and queens. Sculptor - Pedro Mira

hold her disguise as Kamar, she married Princess Hayat al-Nufus. But Armanus grew weary when Budur wouldn't sleep with Hayat, and he told her daughter that 'Kamar' would be banished if he did not take her maidenhead. Budur told her story to Hayat. She pitied Budur, so they used pigeon blood to make it seem Hayat had lost her maidenhead.

The gardener told Kamar that he would arrange a ship to bring him to Muslim lands. Meanwhile, while weeping in the garden, Kamar saw two birds fight, and by fate, the jewel of Budur was with the dead bird just slain in the fight. The gardener told Kamar that the ship would sail to Ebony Island shortly. Kamar gathered fifty leather bottles with olives inside, and he hid the jewel in one. After the bottles were loaded on the ship, the gardener got mortally ill, so Kamar stayed on shore to bury him. When he returned to the ship, it had already sailed off without him.

The ship arrived at the Ebony Islands, where Queen Budur bought the olives; in them, she found her Jewel. She recognized it and ordered the ship and crew to bring the merchant of the goods to her. After the merchant revealed where the olive jars originated from he ordered them to find Kamar. They sailed off, and when Kamar was eventually brought to her, Budur hid her identity. She had him take a bath and then seduced him, revealing that she was Budur, his beloved. The following day she told the whole story to King Armanus, including the fact that his daughter still had her maidenhead. The King marveled at the story and married his daughter to Kamar with Budur's consent, making Budur and Hayat sister wives.

The Fisherman and The Merman

There was once a Fisherman named Abdullah who had a large family of nine children and their mother. He was poor, save his net, so every day he went fishing. If he caught a little, he sold it and spent the price on his children, saying, "The daily bread of tomorrow will come tomorrow." His wife gave birth to another child, making a total of ten. That day, he had caught nothing, not so much as a minnow. Trudging home and saying to himself, "What shall I do and what shall I say to the children tonight?" He came to a baker's oven and saw a crowd about it. The fisherman stood looking and smelling the hot bread till the baker saw him and cried out, "Come hither, fisherman!" So he approached him, and the baker said, "Dost thou want bread?" But he was silent. "Speak out and be not ashamed. If thou have no silver, I will give thee bread." The fisherman said, "I have no money indeed!" The baker said, "Take what you need, and I will have patience until better luck betides thee." He returned to his wife and children, who were weeping for hunger, and he set the bread before them, and they ate. The next day he shouldered his net and went forth to the seashore and cast his net, but there came up no fish again. He set out homewards and past the baker hastening his pace so the baker would not see him. The baker saw him anyway and cried out, "Fisherman! Come and take thy bread and some spending money." Abdullah said, "I was ashamed to face thee because I have caught no fish this day." "Be not ashamed." Then he gave him bread and the ten coins, and he returned and told his wife.

This went on for many days until the fisherman was significantly in debt to the baker. One day he cast his net, pulling it in, and found it heavy. When he got it ashore, he saw a man in it and took him for a genie. The merman called out to him from within the net and said, "Come fisherman and flee not from me, for I am part human. Release me." The fisherman took heart and said to him, "Who threw thee into the sea?" The other answered, "No one. I am a child of the sea. I was going about therein when thou cast the net over me. Will you set me free, make a covenant with me, and become my comrade? I will come every day to this place, and you come to bring gifts of the fruits of the land and I the sea. For with you are grapes and figs and peaches and so forth. With us are coral, pearls, emeralds, rubies, and other gems." The fisherman agreed, loosened the Merman from the net, and asked him, "What is thy name?" He replied, "My name is Abdullah of the sea. What is thy name?" The fisherman returned, "My name also is Abdullah;" "Thou art Abdullah of the land, and I am Abdullah of the Sea! Wait here till I fetch thee a present." Abdullah, the merman, returned with both hands full of pearls, coral, rubies, and a basket filled with fish. They then parted ways.

Abdullah, the fisherman, rejoiced and returned to the city. He came to the baker and said, "I owe thee much money, but take this." He took a handful of the pearls and rubies and gave them to the baker. The baker became a faithful friend to him. The next day the fisherman filled a basket with fruits, returned to the seashore, set down the crate on the water edge, and called out, "Where art thou, Abdullah, the Merman?" He answered, "Here am I, at thy service," and came forth. The fisherman gave him the fruit, and the

merman took it, plunging into the sea, and was absent a full hour. When he came to the surface again he had a basket full of gems and jewels. Abdullah went to the city and exchanged the jewels and rubies for bread and other foods. Then he took a gem to the jewel bazaar. He showed them to the Syndic, and the jeweler knowing him to be poor, accused him of stealing them and brought him before the king. The king finding there was no robbery, said to Abdullah, "No harm shall befall thee. But tell me truly, where did you obtain these jewels, for I am a King." The fisherman told him of his friendship with the Merman, adding, "We have made a covenant together that every day I shall bring him a basket of fruit and that he shall fill the basket with these jewels."

It's bulk is greater than that of any beast of the land. Have no fear, when he sees thee, he will know you for a son of Adam and will fear thee and flee." Sculptors - Denis Kleine, Bob ATISSO & Yosef Bakir

"Wealth needs rank. I am minded to marry thee to my daughter and make thee my Vizier." The king honored his family and established him with royal rank and privilege.

Abdullah continued exchanging the fruits of the land for those of the sea and enjoyed his new wealth and happiness. One day the two were conversing and the talk continued until it fell upon the subject of tombs. "They say that the Prophet is buried with you on the land. Know you his tomb?" Abdullah replied, "Yes. It lies in a city called Yathrib." "Come with me into the sea, that I may entertain thee in my house and give thee a deposit which thou must take to the Prophet's tomb.'" The fisherman replied, "If I went into the sea, the water would choke me." Retorted the

The Merman carried him to another city and another until he had the sight of eighty cities. Then they came to the Merman's home, "This is my city."

other, "Have no fear for that, for I will bring thee an ointment, and naught shall harm thee." Asked the fisherman, "What is this Ointment?" And the Merman answered, "It's the liver fat of a fish called the Dandan, which is the biggest of all fishes. Its bulk is greater than that of any beast of the land. Have no fear. When he sees thee, he will know you for a son of Adam and will fear thee and flee. They only need to hear a single man's cry, and they die." He rubbed his body from head to heels with that ointment. Then he descended into the water, opened his eyes, and beheld the water brought him no harm. The Merman said, "Follow me." They came to a high mountain when suddenly, he heard a mighty cry. A black thing, the bigness of a camel or bigger, was coming down upon him. "This is the Dandan, so cry out at him, or he will devour you." Abdullah cried out at the beast, and it sank dead. Then they swam until they arrived at a city with all women inhabitants. "This is the city of the women of the sea. The King of the sea banished them here, and they cannot leave. The fisherman fell to gazing upon those women, whom he saw with faces like moons and hair like women's hair, but they had tails like fish. The Merman carried him to another city, which he found full of male and female folk, but there was neither selling nor buying amongst them, nor were they clothed. Abdullah said, "I see males and females alike with their shame exposed, " and the other said, "This is because the folk of the sea have no clothes." The fisherman asked, "And do they marry?" The Merman answered, "They do not always marry, but everyone who has a liking to each other doth

there will." Abdullah asked, "Why does he not ask her in marriage following that which is pleasing to Allah?" "We are not all of one religion. Some of us are Muslims, believers in The Unity, others Nazarenes and each marries following the ordinances of his creed."

The Merman carried him to another city and another until he had the sight of eighty cities. Then they came to the Merman's home, "This is my city." Abdullah of the Land looked and saw a city that was small compared to those he had seen before. They came to a cave. "This is my house. All the houses in the city are like this, caverns great and small in the mountains." Abdullah entered and saw the Merman's daughter with a face like the rondure of the moon with long hair, heavy hips, black-edged eyes, and a slender waist, but she was naked and had a tail. When she saw Abdullah of the Land, she said, "what is this No-tail thou hast brought with thee?" He replied, "This is my friend of the land who used to bring us the fruits of the ground." Before long, in came the Merman's wife with her two children, each having in his hand a young fish, which he crunched as a man would crunch a cucumber. When she saw the fisherman, she said, "What is this No-tail?" She and her sons and their sister came up to him examining the back parts of Abdullah and saying, "Yea, by Allah, he is tailless!" And they laughed at him. So he said to the Merman, "hast thou brought me here to make me a laughingstock for thy children?" "Pardon, those who have no tails are rare among us. Excuse these young children and this woman, for they lack wits." As they were talking, in came ten Mermen, and one said, "Abdullah, it hath reached the King that thou hast with thee a No-tail." The Merman answered, "Yes, but he is my friend and hath come to me as a guest." "We cannot depart without him, so come with him before the King." So he took him to the King, who, when he saw him, laughed and said, "Welcome to the No-tail!" The merman interjected, "This man is of the land, my comrade, and cannot live amongst us. I desire that thou give me leave to restore him to the land." The King replied, "I give thee leave after due entertainment," So they ate, and the king gave him gifts of jewels and rubies, after which the Merman pulled out a purse and said to him, "Take this deposit and lay it on the tomb of the Prophet!" Then the Merman went forth with him to bring him back to the land. On the way, he saw a table spread with fish and folk eating, singing, and holding a high festival. Abdullah of the Land asked, "Why do these people rejoice thus?" Abdullah of the Sea replied, "One of them is dead." The fisherman asked, "When one dies amongst you, you rejoice and sing and feast?" The Merman answered, "Yes: and ye of the land, what do you?" "When one dies amongst us, we weep and mourn for the dead." Abdullah the Merman stared at him wide-eyed and said, "Give me back the deposit!" Then he set him ashore and said to him, "I have broken off our friendship. From this day forward, thou shall see no more of me, nor do I see thee." The fisherman cried, "Why?" The Merman replied, "How can I entrust thee with a deposit for the Prophet, seeing that, when a child is born, you rejoice in it, although life is just a temporary deposit? Yet, when he, the Almighty, takes it back again, it is grievous to you, and you weep and mourn? How can I trust you when you don't trust Allah?" Saying this, he left and disappeared into the sea. He continued to go down to the shore and call upon Abdullah of the Sea for some time, but he answered not. At last, he gave up, and he and his family lived happily and practiced righteous ways until they died.

The Talking Bird, The Singing Tree, and The Golden Water

There were once two brothers named Bahman and Perviz who had a close friendship with their only sister Parizade. They had never known their father, Sultan Khosroo Shah for they had each been stolen from the palace when they were a day old. On each occasion, when the Sultan asked to see the babies, two wicked aunts, who had spite against their sister, told him they were not children at all. They were only a dead dog, a cat, and a piece of wood. The aunts stole the real babies, wrapped them in flannel, placed them each in a basket, and sent them, one after the other, adrift down the canal.

The keeper of the sultan's gardens found the first one floating down the river, adopted him, and named him Bahman. After a time, the keeper saw another floating basket, and he and his wife adopted the baby in exactly the same way and named him Perviz. Later they found a third basket containing a little princess, whom they called Parizade. The keeper and his wife grew so fond of these children that they determined not to inquire about the children's origin nor to tell them that they were not their own. The keeper built them a country house surrounded by woods, meadows, and corn land and furnished it magnificently. Only six months after completing this, the keeper died so suddenly that he could not give the princes and princess any account of the mystery which hung over their birth. Bahman, Perviz, and Princess Parizade, content with the plentiful fortune he left them, lived together, free from ambition.

One day when the two princes were hunting while Princess Parizade stayed at home, a religious woman came to the gate and desired to come in and say her prayers. The Princess granted her request and gave her a tour of the house and

The aunts stole the real babies, wrapped them in flannel, placed them each in a basket, and sent them, one after the other, adrift down the canal.

The keeper of the Sultan's gardens found the first one floating down the river, adopted him, and named him Bahman.
Sculptor - Andrey Vazhynskyy

gardens. She asked her what she thought of the property. "Madam," answered the devout woman, "It is beautiful, regular, and magnificently furnished, and all its ornaments are in the best manner. No garden can be more delightful. But if you give me leave to speak my mind freely, I will say that this house would be incomparable if it had three lacking things." "My good mother," replied Princess Parizade, "what three things? I will spare no trouble to get them." "Madam," replied the devout woman, "the first is the speaking bird, The second is the singing tree, and the third is the water of gold. I am glad to tell you that these three things can be found in India. The road to it lies before your house. Follow it for twenty days, and on the twentieth, ask the first person you meet where the speaking bird, singing tree, and golden water are, and you will be informed." After these words, she rose, took leave, and went her way.

When her brothers returned from hunting, instead of finding Princess Parizade lively as usual, they were amazed to see her hang her head. Prince Bahman said, "Sister, has some misfortune befallen you?" "This day, I have learned that our house needs three things to render it perfect. These three things are the speaking bird, the singing tree, and the golden water." Then she told them all about the visit of the religious woman. "I am convinced that they are absolutely necessary." "Sister," replied Prince Bahman, "what concerns you concerns us. We will search for them; only tell me where the place is."

Early the next morning, Prince Bahman mounted his horse, pulled a knife out of his pocket, and, presenting it in the sheath to the princess, said: "Take this knife, sister, and sometimes pull it out of the sheath: while you see it clean as it is now, it shall be a sign that I am alive; but if you find it stained with blood, then you may believe me dead." He bade farewell and rode away well-armed and equipped. On the twentieth day, he saw by the roadside a hideous old man, a dervish, who sat under a tree a small distance from a thatched house. His eyebrows were white as snow, and so was the hair on his head. His beard and hair reached down to his feet. The nails on his hands and feet were extremely long. A flat, broad hat, like an umbrella, covered his head. He had no clothes but only a mat thrown around his body. Prince Bahman stopped when he came near the dervish, being the first person he had met, and said, "I am in search of the speaking bird, the singing tree, and the golden water. If you know, I beg you to show me the way." While speaking, the prince observed that the dervish looked very serious. "Sir," he said, "The danger to which you are going to expose yourself is greater than you can believe. Many gentlemen have passed by here and asked me the same question, and I can assure you they have all perished. If you have any regard for your life, take my advice: go no further. Return home." Prince Bahman persisted, "whatever the danger may be, nothing shall make me change my mind. If anyone attacks me, I am well armed." The dervish replied, "But they who will attack you are not seen, and there are many of them. How will you defend yourself against an invisible enemy?" "It is no matter," answered the prince. "Tell me, and do not refuse."

The dervish put his hand into a bag, pulled out a bowl, and gave it to him. "Take this bowl and throw it before you. Follow it to the foot of a mountain. When the bowl stops, leave your horse and go up the hill. You will see a great quantity of large black stones and will hear voices on all sides of you, saying a thousand things to discourage you and prevent you from climbing the hill. Be not afraid, and do not turn your head to look behind you. If you do, you will become a black stone like those you will see. All of which are the many gentlemen who have failed. If you escape the danger and get to the top of the mountain, you will see a cage, and in that cage is the bird you seek. Ask him where the singing tree and the golden water are. He will tell you." After these words, Prince Bahman mounted his horse, took leave of the dervish, and threw the bowl before him. The bowl rolled away swiftly with Prince Bahman behind it. When it came to the foot of the mountain, it stopped. Seeing the black stones, the prince began to climb the mountain but had not gone four steps before he heard the voices. Some said, "Where is that fool going? What does he want? Don't let him pass." Others, "Stop him, catch him, kill him!" And others with a voice like thunder,

His beard and hair reached down to his feet. The nails on his hands and feet were extremely long. A flat, broad hat, like an umbrella, covered his head. He had no clothes but only a mat thrown around his body. Sculptor - Guy-Olivier Deveau

"Thief! Assassin! Murderer!" Prince Bahman mounted with courage and resolution for some time. At last, he was seized with fear, turned about to run down the hill, and changed into a black stone.

From the time of Prince Bahman's departure, Princess Parizade always wore the knife and sheath in her girdle and pulled it out several times a day to know whether her brother was alive. On the fatal day that Prince Bahman was metamorphosed into a stone, the princess drew out the knife and, seeing the blood run down the point, was seized with grief. Prince Perviz did not waste time in needless regret, as he knew she still desired the possession of the speaking bird, the singing tree, and the golden water. He interrupted her, "Sister, our regret for our brother is vain and useless. It is the will of God. It ought not to prevent us from pursuing our object. I offer to go on this journey." The princess did all she could to dissuade Prince Perviz not to expose her to the danger of losing two brothers, but it had no effect on him. Before he went, he left her a string of a hundred pearls, telling her that if they became fixed, he would have befallen the same fate as his brother.

On the twentieth day after setting out, he met with the same dervish in the same place as his brother before him. He asked if he could tell him where to find the speaking bird, the singing tree, and the golden water. The dervish made the same remonstrances as he had done to Prince Bahman. "Good dervish," answered Prince Perviz, "I cannot give it up. Therefore, I beg you to do me

Bahman mounted his horse, took leave of the dervish, and threw the bowl before him. The bowl rolled away swiftly with Prince Bahman behind it.
Sculptor - Radovan Zivny

the same favor as you did my brother. "Since I cannot persuade you to give up, I will give you a bowl I have here to show you the way." He gave it to him with the same directions as he had given Prince Bahman. Prince Perviz threw the bowl before his horse, and when it came to the bottom of the hill, it stopped, and the prince got off his horse and stood some time to recollect the dervish's directions. He began to walk up with a resolution to reach the top, but before he had gone six steps, he heard a voice say, in an insulting tone, "Stay, rash youth, that I may punish you for your boldness." At this insult, the prince forgot the dervish's advice, clapped his hand upon his sword and drew it, and turned about to avenge himself. He and his horse were instantly changed into black stones.

In the meantime, Princess Parizade was pulling over the pearls as usual when suddenly she could not stir them. Her brother was dead. She lost no time in grief and disguising herself in man's apparel, she mounted her horse the following day. The princess journeyed the same days as her brothers and met the dervish. She alighted off her horse and said, "Tell me if there is a speaking bird, a singing tree, and golden water somewhere." " Madam," answered the dervish, "I know where these things you speak of are, but what makes you ask this question?" "Good dervish," replied the princess, "I have a great desire to possess them." Then the dervish repeated to Princess Parizade what he had said to Princes Bahman and Perviz. The princess replied, "The first difficulty is getting up to the cage without being frightened by the voices. The second is not looking behind. I intend to stop my ears with cotton so that however loud and terrible the voices may be; they will make less impression upon my imagination." He repeated the exact instructions he had given her brothers. After the Princess thanked the dervish, she mounted her horse, threw the bowl before her, and followed it till it stopped at the foot of the mountain.

The princess stopped her ears with cotton wool, and the voices could not make any impression on her. She got so high that she began to see the cage and bird, which also tried to frighten her, crying in a thundering voice, "Retire, fool, and come no higher." The princess got to the top of the mountain, where the ground was level, and running straight to the cage, clapped her hand upon it, and cried, "Bird, I have you."

While Princess Parizade was pulling the cotton wool out of her ears, the bird said, "be not angry with me for joining in with the voices. Since I am destined to be a slave, I would rather be yours than any other person since you have obtained me courageously and worthily. From this instant, I swear faith to you, but the time will come when I shall do you a service, for which you will feel obliged to me. The princess answered, "Bird, I wish for golden water. I ask you where it is." The bird showed her the place, and she went and filled a little silver flask. She returned to the bird and said, "I also want the singing tree. Tell me where it is." "Turn round," said the bird, "and you will see behind you a wood where you will find this tree." The princess went and soon knew the tree among the others, but it was very large. She returned to the bird and said, "I have found the singing tree, but I can not pull it up by the roots nor carry it." The bird replied, "Break off a branch to plant in your garden."

When the Princess had the three things, she said to the bird, You have been the cause of the death of my two brothers, who must be among the black stones. I wish to take them home with me." The bird said, "Look if you can see a little

Then the princess led him to the spot where the singing tree was planted, and the sultan heard a concert there. "Tell me whether this wonderful tree was found in your garden. What name do you call it?"
Sculptors - Uldis Zarins, Bouke Atema & Agnese Rudzite Kirillova

He met with the same dervish in the same place that his brother before him. He asked if he could tell him where to find the speaking bird, the singing tree, and the golden water. Sculptor - Radovan Zivny

pitcher. Take it and spill a little water upon every black stone as you go down the hill, and that will be the way to find your brothers again." Princess Parizade took the pitcher, and as she went down the hill, she spilled a little of the water on every black stone, which was changed immediately into a man until she did her brothers. When they resumed their former shape, they were indebted to their sister, as were all the other gentlemen, who all declared they were ready to obey her in whatever she should command.

Princess Parizade led the way back. When they called upon the dervish to thank him they found him dead. They pushed on and lessened in number every day as the gentlemen took leave of them one after another. As soon as the princess reached home, she placed the cage in the garden, and the bird began to sing. Nightingales, chaffinches, larks, linnets, goldfinches, and many others birds of the country joined the talking bird in song. As for the branch of the singing tree, it was set in the middle of the garden, where it took root, and became very large. The leaves of which gave as harmonious a concert. As to the flask of golden water, a large basin of beautiful marble was made. The princess poured all the golden water into it, and it increased and swelled so much that it soon reached the edges of the marble basin. A twenty-foot-high fountain formed in the middle, which fell again into the basin perpetually. The report of these wonders spread abroad and many people came to admire them.

Word reached the Sultan of Persia, who came to see the wonders himself. Upon meeting

Princess Parizade took the pitcher, and as she went down the hill, she spilled a little of the water on every black stone, which was changed immediately into a man until she did her brothers. Sculptor - Greg J Grady

Bahman and Perviz, He thought he might have had children just their age if he had been more fortunate. They invited him to do them the honor of being a guest at their house, and he agreed. "Then," replied the princess, "we must think at once of preparing a feast fit for his majesty. We should consult the speaking bird. He will tell us what dishes the sultan likes best." She consulted the bird alone. "Bird," said she, "the sultan will come and see our house, and we are to entertain him. Tell us what we shall do." The bird replied, "You have excellent cooks. Tell them to prepare a dish of cucumbers stuffed with pearls, which must be set before the sultan in the first course." "Cucumbers with pearls!" Cried Princess in amazement. "Surely, bird, you do not know what you say." "Mistress," said the bird, "do what I say. Nothing but good will follow."

The princess called for the head cook, and after she had given him directions, she said, "besides all this, you must prepare an extraordinary dish of cucumbers stuffed with pearls." The chief cook stared back and showed his thoughts by his looks. The princess said, "I am not mad, and I give you these orders sincerely. You must do the best you can."

That evening, as the Sultan entered the courtyard, Princess Parizade came and threw herself at his feet, and the two princes informed him that she was their sister. The sultan stooped to help her up, and, after he had gazed some time on her beauty, struck with her noble air, he thought he could have had a daughter this age if he had better fortunes. "My fair one," he said to Princess Parizade, "do you call this a country house? The finest and largest cities would soon be deserted if all country houses were like yours. Now let me see the garden." The princess led them into the garden, and the first object the sultan saw was the golden fountain. Surprised at so rare a sight, he asked whence such water came. Then the princess led him to the spot where the singing tree was planted, and the sultan heard a concert there. "Tell me whether this wonderful tree was found in your garden. What name do you call it?" "Sir," replied the princess, "this tree has no other name than that of the singing tree. It would take too long to tell you how it came here. Its history is connected with the golden water and the speaking bird, which came to me at the same time. "I am impatient to see and admire the speaking bird." Said the sultan. As he went towards the hall, the sultan perceived a prodigious number of singing birds in the trees filling the air with their songs. The sultan went into the hall, and as the bird continued singing, the princess raised her voice and said, "Here is the sultan; pay your respects to him." The bird stopped singing that instant, and all the other birds ceased one after another and said, "The sultan is welcome here; Heaven prosper him and prolong his life!"

As the meal was served, the Sultan saw the dish of cucumbers set before him. Thinking they were stuffed in an ordinary manner, he reached out his hand and took one, but when he cut it, he was surprised to find it stuffed with pearls. "What is this?" He looked at the princes and princess to ask them the meaning of it when the bird interrupted him. "Can your majesty be astonished at cucumbers stuffed with pearls, which you see with your own eyes, and yet so easily believe that your wife had a dog, a cat, and a piece of wood instead of children?" This illuminated the sultan's understanding. "Bird," cried he, "I believe the truth of what you tell me. Come then, my children, my daughter, let me embrace you, and give you a father's love and tenderness."

I will say that this house would be incomparable if it had three lacking things." "My good mother," replied Princess Parizade, "what three things? I will spare no trouble to get them." "Madam," replied the devout woman, "the first is the speaking bird, The second is the singing tree, and the third is the water of gold. Sculptors - Ken Barnett & Lucinda Wierenga "Sandy Feet"

ARABIAN NIGHTS ~ SCULPTURE PARK MAP

Part III

The Storm

I felt overwhelmed one evening as I walked through the sculpture park. It was close to halfway complete, and remarkable sand sculptures, as tall as buildings, surrounded me. Months of design and development were becoming a reality, and I was the creative director. I had envisioned this project full-time for half a year. I planned and plotted with Ted over the phone and by email daily. I virtually lived in this sculpture park via drawings, and 3D models, studying the stories, researching architectural styles, and collecting reference artwork. I drafted plans, created timelines, and sketched designs. I even conscripted my Industrial Design studio colleague, Bryn, to help. We modeled the entire

The poundup crew heading in for another day at the office.

Sybren Huizinga tops up the palace poundup, fifty two feet high.

Sculptor Fred Dobbs. One of the Big 5. Here you can see him digging out a huge stone. No doubt it was put there on purpose. That is known as shenanigan on a sand sculpture plot. Big plot, big shenanigans.

park in block form to do virtual walkthroughs, calculate sand tonnage, and visualize the whole park. What was in my mind's eye was becoming a reality.

Ted and Brian had assembled seventy of the most brilliant sand artists from around the world, and all were doing their best work. The sand was strong, and the sculptors had pushed it to its limits. Their competitive nature was coming out, and they were trying to outdo each other creatively and technically. It was stunning to witness. My heart swelled with pride, and my eyes were wet as I took it all in. It was my life's work. But Karma, Allah, or bad luck had different plans for us. A rare fifty-year storm hit Kuwait and pulverized our sculpture park. It rained so hard that people were jet skiing in the city streets. It didn't stop at one day. It rained like this for three days in a row.

I had been struggling with our event producers to purchase glue and provide a crew to spray these monstrous sculptures. A diluted wood glue and water mixture is typically sprayed on a sand sculpture exterior. This step adds no structure to the sculptures but provides a protective layer against wind and rain. Glue supplies were part of the plan and should have been on site when we arrived. As with most of our plans, things didn't go as planned.

Tech lead Lucas Bruggemann looking confident.

The calm before the storm. The photo shows the palace tower the day before the storm. It was looking great and we felt like we were on top of the world.

It was a vast and ambitious project. Six football fields in size. Thirty thousand tons of sand. Seventy artists and months to construct and sculpt. There would also be lighting, landscaping, entertainers, and marketing. I believe money was tight, but money problems were well hidden from us at the time. I understand now since I hid the logistics problems from our sculptors. Daily promises that the supplies would arrive the next morning were not delivered on. This delayed the spraying of the sculptures.

Lucky for us, the project was adjacent to the site of a sand job we did for the same client six months earlier. Ted and I searched that location and found a dozen large bottles of glue that were left behind in a storage tent. We felt like we had found buried treasure. That evening we purchased all the backpack sprayers available at the hardware store. Joris and Bouke cobbled together a large mixing and dispensing station out of a discarded water cube. We managed to spray the sculptures partially with what we had scrounged together. It could have been much worse if we hadn't.

Hard rain beat down on the sculptures for three days straight. On the first day, we went in

Sybren Huizinga and Martin De Zoete take in the chaos of the site.

with a small crew on the advice of Sybren, who had experience with sand park disasters. He was an excellent equipment operator who had worked on numerous large-scale sand parks that are a regular occurrence in Europe. We assessed the damage and devised a recovery plan. Lucas, our other lead tech, recommended we build ladders and focus on cleaning the site up. This would lessen the apocalyptic appearance for the rest of the artists and make for a clean restart.

It wasn't only the storm damage that made the site look so apocalyptic. There were two thousand forms to build, organize, store, and deploy. I had drawings and plans for everything but a "form foreman" was a job title we had overlooked. We were lucky Delayne volunteered when he arrived with the first of our crew. I arrived two weeks later. On my first day I went to inspect the forms and was confronted with so many stacks my head spun and I vomited. It didn't help that Ted and I had drank a bottle of bourbon the night before in celebration of the start of this crazy job. Even though Delayne was contracted as an artist I needed him to continue managing the form deployment. This job grew into running a local labor crew to deal with construction debris, general garbage and removing the numerous wooden forms from the poundups as the sculptors carved their way down. It was a tremendous job and after many weeks of doing it I could see it taking it's toll on him. Just prior to the storm hitting, I told Delayne to start sculpting. As soon as Delayne wasn't the form foreman, the labor crew disappeared and the site cleanup was no longer getting done. Forms, lumber, banding wire, and garbage had accumulated around the site and was now half submerged in murky pools, adding to the look of chaos and ruin.

It was heartbreaking to see the sculptures being destroyed.

Ivan hangs his head in front of the heavily damaged Forty Thieves sculpture. The impact was overwhelming.

Delayne Corbett, sculptor and the Form Foreman.

On the first storm day, I walked the site with Ted. We thought the damage wasn't too bad. By the third day, we watched large chunks fall off the sculptures everywhere we looked. It was a terrible feeling. At one point, I lost contact with Ted and drove around the site looking for him. I feared he might have had a heart attack in the McDonald's bathroom beside the site. That was our clean bathroom and air-conditioned area of refuge. So I headed straight for the bathroom stalls with tense anticipation. They were all empty. It turned out he was off-site, taking shelter from the stress of this calamity.

We used an excavator and pushed the water out, dug drainage channels, cleared out all the refuge, built ladders, and prepared for the rest of the crew to come in and recover. One person was grinning ear to ear through all this, and that was Wael, the filmmaker. It was both frustrating and uplifting to see him revel in this drama.

After the storm passed, I gave the artists a speech to inspire them before we headed into the destruction. This idea wasn't my natural inclination, as I am terrified of public speaking. Something was needed, however, and the underdog football coach speech seemed appropriate. The Europeans thought it was corny. The North Americans got a moral boost. The next day, the producers put on a lunchtime feast with a DJ for us. Then, we dug in. Up the ladders and man lifts we went, patching and re-carving lost heads, arms, and towers. After being utterly decimated, we reconstructed the sculpture park and carried on to completion. This is called a "good recovery" in the sand sculpting world.

The couch was a nice touch and survived the storm.

This sums up the feeling we all had in the moment.

Sculptor Pedro Mira digs a hole in his sculpture to let the water flow out.

118

The top of the palace just before the storm.

Ken Abrams digs a drainage channel to help clear the water flooding the site.

We watched to storm destroy more and more of our masterpiece as it continued for three days straight.

This photo is just before the tower top melted away. It was looking like the entire palace base was going to liquefy and turn to mud. If the storm carried on much longer it might have.

Up the ladders and man lifts we went, patching and re-carving lost heads, arms, and towers. After being utterly decimated, we reconstructed the sculpture park and carried on to it's completion.

A few weeks after we completed the park and had all returned home, a storm hit Kuwait again. We assembled a crew of fifteen artists and returned for another two weeks to repair the damage. I remember telling Susanne Ruseler, who wasn't on the original team, to not look at it all and to focus on what was in front of her. It was simply overwhelming to take in all the destruction to our sculptures. She did say it was one of the most remarkable projects she had ever seen, even with all the damage. We fixed the park once again, but that still wasn't enough. The exhibition got hit with a third storm just before opening.

This book is a testament to the team's grit. Despite tremendous odds and adversity, we finished one of the largest and most technical sand sculpture parks ever constructed. Many of the photographs in this book were taken after the storm damage and repairs. You, the reader, can be the judge.

One person was grinning ear to ear through all this, and that was Wael, the filmmaker. It was both frustrating and uplifting to see him revel in this drama.

Dmitry Klimenko & Ivan Zverev in better spirits and ready for a great recovery.

The Enchanted Horse

Many centuries ago, in the time when science still mingled with magic, Shah Sabur was lord and master of Persia. This wise ruler delighted in every new and ingenious invention of the times. One festival day, three ingenious men, skilled and cunning in the art of invention, came to his court. First, the Indian unveiled his work; a golden statue of a soldier blowing a trumpet. "And what is the point of this? "My Lord, place this statue by the gate to your palace, and if an enemy approaches,

The prince leaped onto his horse, turned the screw, and all watched as it began to judder and rock, and it took off into the air flying above the heads of the army. Sculptors - Uldis Zarins, Alexsey Samolov, Aleksandr Skarednov, Denis Bespalov & Max Bespalov

the golden guard will sound his trumpet, and the evil one who means you harm shall fall dead." The king suppressed a yawn. "I have something like that already," he replied. "Next!" The inventor from Greece stepped forward, presenting a diamond-studded cockerel. "And the point is...?" inquired the King. "My Lord, you will always know the time. This golden bird shall cock-a-doodle-do on the hour every hour. The king was unimpressed. "And why should I care what the time is? Next!" Third, the Persian inventor took his turn. "I hope for the sake of your neck that you have something novel to show me." Said the king. The inventor snapped his fingers, and six men shoved and heaved a

His finger twiddled a nob in the back of its neck, and the horse immediately took off into the air. It climbed steeply up above the heads of the gasping spectators before descending gently back to the lawn.

large black ebony statue of a horse. "And what is the point of this?" Asked the king. "Allow me to demonstrate." The inventor jumped onto the horse's back. His finger twiddled a nob in the back of its neck, and the horse immediately took off into the air. It climbed steeply up above the heads of the gasping spectators before descending gently back to the lawn. "I must have that horse. Name your price inventor." "My invention is worthy of the highest price. I crave nothing less than the hand of your daughter, the princess, in marriage." Those who stood nearby and heard these words were astonished, for it was daring of this inventor. Perhaps the king was under some spell, for he replied, "Granted."

The King's son was among those who overheard this. He was furious that the king should dishonor his family by giving away the princess to such a scoundrel. "Oh father," he pleaded, "I fear you have been greatly deceived. This trickster's flying horse is nothing more than an illusion, the sort you can see in the marketplace any day. His art is not invention but hypnotism. He has made fools of our eyes." The inventor replied. "I invite the prince to mount the horse and see for himself what power it holds." The prince, who was a splendid rider, mounted it and struck its ebony sides with his stirrups, but it made no move. "Ha! It's useless!" He cried. The inventor looked up and said, "My Lord, feel under the horse's main. There is a little screw there. Turn it to the right and behold the wonder of the horse." Immediately, the horse climbed into the sky and headed for the sun. The king was perplexed and cried: "By he who rules the universe, bring him back, for he is my one and only son." The King was overcome with furious rage. He called for the guards to take the inventor down to the dungeons and clap him in irons. The news soon spread around the town that the King's son was gone forever, and all the people wept and cried, for he was a popular prince.

Meanwhile, The prince soared on through the sky, the wind rushing through the air. He felt under the main and found another pin. He could not be entirely sure what would happen if he turned it. He tried it. The flying horse ceased its ascent and began to level off. The prince experimented with the controls, and soon he was the master of the machine. He did not know where he was going, but he was over the Kingdom of Bengal. Eventually, he saw a thriving town and a magnificent palace with lofty towers and battlements. He thought, "That is where I shall come down to land, for it is plain for all to see that

I am of royal birth, and this is where I shall receive a royal reception."

After nightfall, he gently landed on the flat roof of the palace. He dropped down through a skylight and crept through the sleeping palace. He looked around and picked one door at random. The floor was strewn with the forms of sleeping women. In the midst of them all stood a wooden and intricately carved bed with a beautiful princess sleeping in it. He knew he was in imminent danger but no longer feared death. He kissed her cheek. She opened her eyes and seeing the prince said, "You must be the one who came yesterday and asked for my hand in marriage. My father rejected you and told me that you were ugly and uncouth. Now I see he deceived me, for your face is as glorious as the morning sun." He did not deny what she said, and they fell into talking and knew they were destined to love one another. But one of the waiting women heard their talk in her sleep. She awoke and ran out to wake the guard. Seeing that the prince was armed and of noble birth, he ran off to wake the king. The king awoke from his slumber, took a scimitar, and rushed to the princess's chamber with the guard. The King said: "Who are you, who dares to creep into the room of the princess!" And the prince replied, "I am the prince of a mighty kingdom that could

"I am the prince of a mighty kingdom that could crush yours as easily as an ant beneath the foot of an elephant." Sculptor - Radovan Zivny

crush yours as easily as an ant beneath the foot of an elephant. The King replied, "Even if you are the prince of a mighty kingdom, all I need do is call for my guards, and you will be mincemeat in an instant." "And where would the honor be if you strike me down like a common criminal?" Replied the prince. "Hear my proposal. In the morning, bring forth your finest soldiers, and I will face them alone, and everyone shall see what manner of a man has entered your house, no thief or rogue, but the son of Kings!" The king saw the wisdom in this plan, and it would no doubt be wiser and more charming to grant him a death with honor. It was only a few short hours until the sun's rays awoke the sleeping palace, and the king ordered his guards to prepare for battle against the prince.

The King of Bengal reviewed the imperial guard as it lined up before his palace. It was 10,000 in number, and it bristled with spikes and swords. Banners fluttered in the wind. Drums beat, and horses stomped the ground. It was an incredible sight, even for a seasoned general. The prince stood alone and faced the ranks of soldiers. The King stood on the wall of his palace and called out to him: "Now, Prince of Persia, bid farewell to the princess whom you sought to marry without her father's consent." The prince replied, "But king, you do not deal with me fairly. Is it fitting for a prince to go into battle on foot? Bring me my steed, and I shall meet your army on horseback." The king saw no harm in this request and asked him where his horse was tethered. "Go up to the palace's roof and bring me what you find there." It

The King of Bengal reviewed the imperial guard as it lined up before his palace. It was 10,000 in number, and it bristled with spikes and swords. Banners fluttered in the wind. Drums beat, and horses stomped the ground.

The prince leaped onto his horse, turned the screw, and all watched as it began to judder and rock. It took off into the air flying above the heads of the army.

was a struggle for six strong men to fetch the ebony horse. The king smiled when he saw that it was a toy made of wood. Trying not to laugh, he said, "Mount your horse, oh Prince. There are those who would doubt your sanity." The prince leaped onto his horse, turned the screw, and all watched as it began to judder and rock. It took off into the air flying above the heads of the army. When the king saw this, he had the presence of mind to call out, "Archers, shoot him down!" A cloud of arrows took flight but fell short of the magnificent horse. From the safety of the air, the young prince thought of the princess he had left behind and said, "By Allah, I shall not forget you, my dearest Sana," for that was her name. He pointed his flying horse in the direction from whence he had come. When he landed, the whole court was dressed in mourning clothes and grieving his loss. There followed a week of feasting and celebration. The Shah even ordered that the inventor of the flying horse be released. The king rued the day he had bought the internal contraption and forbade his son to ever go near it again. The Prince's fires of passion flamed in his heart. Eventually, he found the opportunity to find the forbidden horse and make the journey to the kingdom of Bengal to find Princess Sana. The prince found her in her chambers, and the prince said fondly, "It is I, returned to carry you back to Persia for our wedding day." "You!" She said, angry all of a sudden. "How could you have left me?" "Would you rather that I was cut down by the soldiers of your father's army?" "Yes," she said, confused. "I mean, no. My only wish is to be with you." And they fell into each other's arms. Away they flew, and they returned to his father's palace. When his father saw the young prince's choice for a bride. He rejoiced in his son's good taste and called for preparations to be made to celebrate. Out of courtesy, messengers were sent to her

father in Bengal. In the meantime, the pleasures of hunting and companionship called the prince away. On one such occasion, the young princess was walking in the garden when an old, rather hideous figure approached her. "Your beloved has had to leave for another city on urgent business. He pines for your lovely face and has sent me to fetch you to him."

The story made perfect sense to the young princess, and as she had already made one successful trip on the flying horse, she was not alarmed when the man asked her to climb on board it. He turned the screw in the neck of the horse, and up they rose into the sky. On and on they flew. "Old Man, when shall we see my prince?" And the inventor called back "You shall never again set eyes on your prince." And he went on, pouring curses on the heart of her beloved. The poor princess knew she was doomed and wept and wailed as they flew. "Do not cry, princess, for I shall marry you!" Eventually, they settled in a calm, gentle field, where they rested in the land of the Greeks. As they slept, a king, who was out hunting, came across them. "Greetings, Who are you? Where have you come from? And what secret lies hidden in the belly of this strange black horse?" The Princess, seeing her chance of salvation, called out, "A wicked magician has abducted me and stolen me away from the arms of my beloved prince." The Greek had no doubt whom he wanted to believe. He ordered his guard to cut off the ugly head of the inventor, and that was the end of him. Then he returned to his palace, taking the lovely princess and the strange ebony horse with him.

Meanwhile, her prince had not ceased grieving the loss of his bride. He traveled from place to place, asking after the ugly magician, the lovely maiden, and the wonderful horse. People thought that his rambling story was an outward sign of madness. After having traveled for over a year, he sat down under a plane tree and heard three merchants talking. They spoke of a king who had encountered an evil magician, a princess, and a mysterious horse carved from ebony. He made careful inquiries and heard that the King wished to marry the princess. Ever since he had made this proposal, she had been stricken with a mysterious illness and refused to leave her bed. The king had offered a considerable reward for any priest, magician, or doctor who could find a cure. Towards supper time, the Prince came to the palace gates, declaring he was a traveling medicine man. When the prince came before the King, the courtiers saw his ragged clothes and heard his foreign accent. He said he was Persian, but the Greeks did not care for the Persians. They laughed and poured scorn on him. But the King said, "I care not if he is Persian or from the moon." He allowed the visitor to see the princess. He went to the king and advised that the demons of madness had overtaken the princess. Fortunately, he had a cure. Powerful candles and fuel for the fire that would burn with sweet-smelling smoke and drive the demons from her body. He ordered the servants to dress the princess in regal clothes and fine jewelry. They led her into the courtyard that was already cloudy with the smoke of incense. The enchanted horse stood by like the statue of a mystical god. The smoke grew thick. It was hard to see anything. When the smoke had cleared, the Prince, the princess, and the wonderful horse had disappeared. A day later, they would be back in Persia, and a week after that, they would be married and live happily together.

Like the statue of a mystical god. The smoke grew thick. It was hard to see anything. When the smoke had cleared, the Prince, the princess, and the wonderful horse had disappeared.

The King of Persia and the Princess of the Sea

The king of Persia was living a successful reign but had no heir. One day he received a message requesting an audience from a merchant. The merchant had the most beautiful woman under his service as a slave and proposed the king make her his wife. She was so beautiful that he fell in love immediately and married her at once. At the end of three days, the Queen was alone in her chamber, sitting on a sofa. Leaning against one of the windows that was facing the sea when the king came in. Hearing somebody walk into the room, she immediately turned her head to see who it was. Without showing the slightest interest or rising from her seat to salute or receive him, she turned to the window again as if he had been the most insignificant person in the world. "Do you mourn for your country, your friends, or your relations?" The king asked but the queen remained silent. The reserve and silence continued for an entire year. They had a son who finally broke her silence. The king asked, "Why did you persist in silence for a whole year?" The Queen answered. "I am far from my own country, without any hopes of ever seeing it again. To have a heart torn with grief at being separated forever from my mother, my brother, my friends, and my acquaintance." The king replied, "The love of our native country is as natural to us as that of our parents, but I thought that a person whose destiny had condemned her to be a slave ought to think herself very happy having a king for her husband.'" "Sire," said the Queen," I am not a slave. My name is Gulnare, Rose of the Sea, and my father, who is now dead, was one of the most potent monarchs of the ocean. When he died, he left his kingdom to a brother of mine, Saleh, and the Queen, my

The king asked, "Why did you persist in silence for a whole year?" The Queen answered. "Far from my own country, without any hopes of ever seeing it again."
Sculptor - Benjamin Probanza

mother. We enjoyed peace and tranquility throughout the kingdom until a neighboring prince, envious of our happiness, invaded with a mighty army. He penetrated as far as our capital and made himself master of it. We had enough time to save ourselves in an impenetrable and inaccessible place with a few trusty officers who did not forsake us in our distress. My brother sent me to be married to a land king to save me. I refused, but in our arguments, My brother had insulted me so intensely that I cast myself out of the sea. The merchant found me and attempted to turn me into his wife. At his failure, he decided to sell me. This is how I ended up as a slave and now with you, the king." "As for your majesty," continued Gulnare, "if you had not shown me all the respect and affection that I could no longer doubt it, I

We enjoyed peace and tranquility throughout the whole kingdom until a neighboring prince, envious of our happiness, invaded with a mighty army.

should not have remained with you. I would have thrown myself into the sea out of this same window and gone in search of my mother, my brother, and the rest of my relations. I hope you will no longer see me as a slave but as a princess worthy of your alliance."

The King was fascinated by all this, and the Queen continued to tell him of her underwater world. "The palaces of the kings and princes are very sumptuous and magnificent. Some of them are of marble of various colors. Others of crystal, mother of pearl, coral, gold, silver, and all sorts of precious stones that are more plentiful there than on earth. I say nothing of the pearls since the largest ever seen would not be valued among us. We can transport ourselves wherever we please in

Then the sea began to rumble, and out of the water, a tall, handsome young man with a mustache of a sea-green color Appeared.

These chariots have a throne upon which the King sits and shows himself to his subjects. The horses are trained so that no charioteer is needed to guide them. Sculptors - Benjamin Probanza & Nicola Wood

the twinkle of an eye, so we have no practical need for carriages or horses. What the King has in his stables are sea horses that are made use of upon public feasts or rejoicing days. Some take delight in riding them and show their skill and talent in races. Others tie them to chariots of mother-of-pearl adorned with an infinite number of shells of the brightest colors. These chariots have a throne upon which the King sits and shows himself to his subjects. The horses are trained so that no charioteer is needed to guide them."

The King said he would like to see her family. Then the sea began to rumble, and out of the water, a tall, handsome young man with a mustache of a sea-green color appeared accompanied by a lady, advanced in years but of a majestic air, attended by five young ladies. "Sister," said the man who was Gulnare's brother, "you now have it in your power to free yourself. Rise, and return with us into my kingdom, that I have reconquered from the usurper." The Queen refused, and this made the King love her even

more. The King invited the Queen's family to stay. Some cultural issues arose over conversation at the meal, and the King and Queen of the sea breathed flames from their mouths and nostrils in anger. The King's kind demeanor resolved the conflict. The next day the King and Queen Gulnare presented their son, Prince Beder, and the King of the sea was so overjoyed that he jumped out of the window with their son into the sea! This frightened the King, but the Sea Queen reassured him that everything would be fine. The sea at length became troubled when King Saleh arose with the young prince in his arms, and holding him up in the air, he re-entered at the same window he went out. The King of Persia was overjoyed to see Prince Beder again, and he was astonished that his son was as calm as before he lost sight of him. It turned out his son was gifted with the ability to breathe underwater like his mother. The Sea King bestowed jewels and precious stones upon the King and Queen Gulnare before they left to return to their own kingdom. The Sea King and Queen were overcome with sadness but also great pride for their daughter's fortunes.

Codadad

In the city of Harran, a magnificent and potent Sultan reigned who had fifty wives. They were all with child, but there was one called Pirouzè, who did not appear to be pregnant. He disliked her and desired that she depart his court. His vizier asked, "May I send her to Sultan Samaria, your cousin." The Sultan approved and sent Pirouzè to Samaria with a letter in which he ordered his cousin to treat her well and, in case she became pregnant, to give him notice. No sooner had Pirouzè arrived in that country when she became pregnant. She delivered a most beautiful prince. The prince of Samaria wrote immediately to the Sultan of Harran to acquaint him with his son's birth. The Sultan rejoiced and answered prince Samer "I desire you to educate him and give him the name of Codadad. Send him to me when I ask for him."

The prince of Samaria spared nothing on the education of his nephew. He taught him to ride, draw the bow, and all other accomplishments so that Codadad was looked upon as a prodigy at eighteen years of age. The young prince, inspired with courage, said to his mother, "I grow weary of Samaria. I feel a passion for glory. Give me leave to seek it amidst the perils of war. Why does my father not call me to his assistance?" "My son," answered Pirouzè, "we must wait till he requires it." "I have already waited too long." Replied Codadad "I will offer him my service as a young stranger and will not reveal myself till I have performed some glorious actions." Codadad departed from Samaria mounted on a white charger, which had a bit and shoes of gold. His housing was of blue satin embroidered with pearls; the hilt of his scimitar was of one single

After days spent in fruitless search, he came to a large plain where in the middle was a palace built of black marble.

diamond, and the scabbard of sandalwood, adorned with emeralds and rubies, and on his shoulder, he carried his bow and quiver. He arrived at the city of Harran and soon found means to offer his service to the Sultan. Charmed by his beauty and promising appearance, the Sultan gave him a command in his army.

The young prince soon gained the officers' esteem and was admired by the soldiers. Having as much wit as courage, he advanced himself in the Sultan's esteem to become his favorite. All the ministers and other courtiers daily resorted to Codadad and were so eager to purchase his friendship that they neglected the Sultan's sons. The princes resented this and developed an implacable hatred against Codadad. The Sultan had such a high opinion of his wisdom and prudence that Codadad was made governor of his brothers.

This only served to heighten their hatred. One of the brother princes proclaimed, "The Sultan, not satisfied with loving a stranger more than us, will have him to be our governor. We must rid ourselves of this foreigner. Let us destroy him by some strategy. We will ask his permission to hunt and when at a distance from the palace, proceed to some other city and stay there some time. The Sultan will wonder at our absence and, perceiving we will not return, might put the stranger to death or banish him from the court."

Codadad granted the permission his brothers desired. They set out but never returned. They had been three days absent when the Sultan asked Codadad where the princes were. "They have been hunting these three days but promised me they would return sooner." As time went on, the Sultan grew uneasy and could not check his anger. "Why did you let my sons go without

At one of the windows was a most beautiful lady, but her hair was disheveled, her garments torn. She called out to him, "Young man, depart from this fatal place, or you will soon fall into the hands of the monster that inhabits it."

bearing them company? Go, seek them immediately, or your life shall be forfeited." He armed himself, departed from the city, and searched the country for his brothers. Hearing no news of them, he abandoned himself to grief. After days spent in fruitless search, he came to a large plain where, in the middle, was a palace built of black marble. At one of the windows was a most beautiful lady, but her hair was disheveled, her garments torn. She called out to him, "Young man, depart from this fatal place, or you will soon fall into the hands of the monster that inhabits it."

She had scarcely done speaking before the monster appeared. He was of monstrous bulk, mounted on a large Tartar horse, and bore a

He was of monstrous bulk, mounted on a large Tartar horse, and bore a heavy scimitar. The prince was amazed at his stature. Codadad drew his scimitar and rushed him. Sculptor - JOOheng Tan

Codadad struck him on his right arm and cut it off. The scimitar fell with the hand that held it, and the giant made the earth shake with the weight of his fall.

heavy scimitar. The prince was amazed at his stature. Codadad drew his scimitar and rushed him, wounding his knee. The giant uttered a dreadful yell and foamed with rage. Raising himself on his stirrups, he made at Codadad with his scimitar. The scimitar made a hissing in the air as Codadad dodged the blow. Before the giant could make a second swing, Codadad struck him on his right arm and cut it off. The scimitar fell with the hand that held it, and the giant made the earth shake with the weight of his fall. Then the prince cut off his head. The lady uttered a shriek of joy and said to Codadad, "Prince, the giant has the keys to this castle. Deliver me out of prison." The prince found the keys and opened the door. The lady cast herself at his feet, and she appeared even lovelier up close. They were interrupted by dismal cries and groans. "What do I hear?" Said Codadad. "They are prisoners that the monster draws out one daily to devour." Said the lady. They advanced towards the dungeon and opened the door. He went down a very steep staircase into a large and deep vault in which over a hundred people were bound to stakes and their hands tied. "I have slain the giant and come to knock off your chains." The prisoners shouted with joy and surprise. They went out of the dungeon and into the court. Codadad was surprised to see his brothers among the prisoners. "Princes," he cried, "am I not deceived?" The princes all made themselves known to Codadad, who embraced them one after another. They gave their most profound gratitude, as did the other prisoners. They then searched the whole castle, finding immense wealth in silks, gold, Persian carpets, satins, and an infinite quantity of other goods. A

considerable part belonged to the prisoners. The prince restored them their own and divided the rest of the merchandise among them. Then they went to the stables, where they found the prisoner's camels and horses, loaded the merchandise, and set on their way.

Codadad asked the lady, "Madam, What place do you desire to go to?" "I am from a country too remote from hence. Besides that, it would be abusing your generosity to oblige you to travel so far. I am a Sultan's daughter. An usurper has possessed himself of my father's throne after having murdered him, and I was forced to flee to save my life. The giant captured me on my travels and hadn't eaten me because he desired to marry me." Since the Princess had no home to go to, Codadad offered his hand in marriage, the Princess consented, and the wedding was concluded that very day in the castle. After which, they set out for the Sultan of Harran's court. After they traveled for several days, Codadad said, "Princes, I have too long concealed from you who I am. Behold your brother Codadad!

His brothers expressed joy outwardly, but in reality, their hatred and jealousy of so amiable a brother increased. They met at night and agreed among themselves to murder him. "We have no other course to choose," said one of them, "for the moment our father learns he is our brother, and that he alone destroyed a giant, whom we could not all of us together conquer, he will declare him his heir." He made such an impression on their envious minds that they immediately went to the sleeping Codadad and stabbed him repeatedly. They left him for dead in the arms of the Princess of Deryabar. They proceeded on their journey to the city of Harran, where they arrived the next day. The Sultan, their father, expressed great joy at their return, asking where they had been. They did not mention the giant or Codadad. They only said they had spent some time in the neighboring cities because they were curious to see different countries.

In the meantime, Codadad lay in his tent, weltering in his blood with the Princess, his wife. The Princess of Deryabar vented her sorrow, fixing her eyes on the unfortunate Codadad. Observing that he still breathed, she ran to a large town to find a surgeon. When she returned with one, they could not find Codadad. The surgeon, unwilling to leave her so distressed, offered her his house and service. He cared for her for some time, during which Pirouzè, Codadad's mother, found them on her search for her missing son. They returned home together, and the Princess of Deryabar found the Sultan at the palace gate, waiting to receive her. He took her by the hand and led her to Pirouzè's apartment. The Princess found her grief redoubled being alone with her husband's father and mother.

His wife. The Princess of Deryabar vented her sorrow, fixing her eyes on the unfortunate Codadad.

All three wept for Codadad. At length, the Princess of Deryabar, somewhat recovered, recounted the adventure of the castle and Codadad's disaster. Then she demanded justice for the treachery of the princes. The Sultan stated, "Those ungrateful wretches shall perish, but Codadad's death must be first made public, that the punishment of his brothers may not cause my subjects to rebel." He directed his vizier to erect a dome of white marble. The dome was soon finished, and within it was constructed a tomb. The Sultan appointed a day to mourn his son when all was completed.

On that day, all the city's inhabitants went to the plain to see the great ceremony performed. The Sultan, attended by his vizier and the principal lords of the court, went in and sat down on carpets of black satin embroidered with gold flowers. A great body of horse guards hanging their heads rode around the dome chanting prayers. A hundred old men, all mounted on black mules and having long gray beards, each carried a book on his head, which he held with one hand. They then rode around the dome, uttering prayers. Then fifty beautiful young maidens mounted on little white horses carrying gold baskets full of precious stones rode thrice around the dome, halting at the same place as the others had done. The Sultan and his courtiers arose, having walked thrice around the tomb, and uttered their words. The dome gate was then closed, and all the people returned to the city. Public prayers continued for eight days; on the ninth, the King resolved to have the princes, his sons, beheaded. The people were incensed at their cruelty towards Codadad and impatiently expected to see them executed. However, Intelligence was received that the neighboring kingdom was advancing with numerous forces and were not far from the city.

This news gave a new cause to lament the loss of Codadad. "Alas!" They said. "Were the brave Codadad alive, we should little regard those who are coming to surprise us." The Sultan formed a large army and bravely marched out to meet them. As soon as the Sultan discovered them, the signal was given, and he attacked with extraordinary vigor. The opposition was not inferior. Blood was shed on both sides, but their enemies, who were more numerous, were upon the point of surrounding him when a great body of cavalry appeared on the plain. The sight of this fresh party daunted both sides. They fell upon the flank of the enemy army with such a furious charge that they soon broke and routed them. They did not stop there. They pursued them and cut most of them in pieces.

The Sultan admired the bravery of this strange cavalry. Above all, he was charmed with their chief, whom he had seen fighting with great valor. Impatient to see and thank him, he advanced toward him discovering Codadad. He became motionless with joy and surprise.
"Father," said Codadad, "perhaps you concluded me to be dead. I should have been so had not heaven preserved me still to serve you against your enemies." "My son!" Cried the Sultan, "is it possible that you are restored to me?" So saying, he stretched out his arms, and they embraced. "I know all, my son," said the Sultan. "I know what your brothers did to you, and you shall be avenged. "Sir," said Codadad, "how could you know the adventure of the castle? Did my brothers tell you?" "No," answered the Sultan, "the Princess of Deryabar has given us an account." Codadad was transported with joy to learn that his wife was at the court.

The Sultan returned to the city with his army and re-entered his palace victorious amidst

As soon as the sultan discovered them, the signal was given, and he attacked with extraordinary vigor. The opposition was not inferior. Blood was shed on both sides.

the people's acclamations, who followed him in crowds. They found Pirouzè and her daughter-in-law waiting to congratulate the Sultan. When they saw the young prince, their embraces were mingled with tears. They asked Codadad by what miracle he was still alive. He answered that a peasant mounted on a mule happened to come to the tent where he lay. He put him on his mule and carried him to his house, where he applied herbs to his wounds and healed him. "When I found myself well," he added, "I returned thanks to the peasant and gave him all the diamonds I had. I then made for the city of Harran, but being informed that some neighboring warriors were on their march against the Sultan, I made myself known to the villagers and stirred them up to undertake his defense. I happened to arrive just in time when the two armies were engaged."

When he was done speaking, the Sultan said, "Let us thank God for having preserved Codadad! The traitors, his brothers who would have destroyed him, should perish." "Sir," answered the generous prince, "though they are wicked and ungrateful, they are my brothers. I forgive their offense and beg you to pardon them." This generosity drew tears from the Sultan, who declared Codadad his heir. He then ordered the princes to be brought out loaded with irons. Codadad struck off their chains with his scimitar. The people were charmed with Codadad's generosity and loaded him with applause.

They fell upon the flank of the enemy army with such a furious charge that they soon broke and routed them. They did not stop there. They pursued them and cut most of them in pieces. Sculptors - Egor Ustyuzhanin & Igor Akimov

"Bring him quick to us, mother, that we may browse upon him with our bellies full." Sculptors - Jihoon Choi & Tae-in Kim

The Prince and the Ogress

Long ago, there was a King who had a son obsessed with hunting. One day the youth set out for the chase accompanied by his father's minister. As they rode together, a large wild beast came into sight. The Prince followed it until he was lost, and the chase escaped him. As the prince wandered the forest, a damsel appeared ahead, and she was in tears. The King's son asked, "Who art thou?" She answered, "I am daughter to a King among the Kings. I was traveling with a caravan in the desert when drowsiness overcame me, and I fell from my beast unwittingly. I am cut off from my people and sorely bewildered." Upon hearing these words, the Prince pitied her. He mounted her on the back of his horse, and they traveled until he passed by an old ruin. The damsel said, "My master, I wish to obey a call of nature." So, he set her down. She was taking so long that the Prince grew suspicious. He followed her without her knowledge and witnessed that she was a ghoul, a wicked ogress. She was speaking to her brood, "My children, today I bring you a fine fat youth for dinner." They answered, "Bring him quick to us, mother, that we may browse upon him with our bellies full." Hearing their talk, the Prince trembled with fear and was about to run when the ghoul caught sight of him. She returned to her disguise and rejoined the prince and asked, "Why art thou afraid?" He replied, "I have hit upon an enemy I greatly fear." The Ghoul asked, "Did thou not say: I am a King's son?" He answered, "Even so." Then she asked, "Why not give thy enemy money to satisfy them?" The Prince replied, "They will not be satisfied with my purse but only with my life." She replied, "If thou be so distressed, ask aid from Allah, who will surely protect thee from evil." Then the Prince raised his eyes heavenwards and cried, "O Thou who answers when called upon, dispel this distress. Oh my God! Grant me victory over my foe and turn them from me, for thou over all things are almighty." The Ghoul, hearing his prayer, turned away from him and disappeared into the forest. The Prince returned safely to his father, the King.

Forms are wooden panels two feet high by different lengths bolted or nailed together to create enclosed rigid shapes. We then compact sand with water in these shapes. This process casts the sand into harder blocks that we call "poundups". We then sculpt these compacted sand blocks as we remove the forms from the top down.
Sculptors - Dennis Storlie, Ken Barnett, Adam Dunmore, Barry Swires

The Wall

The sand walls were hundreds of feet long and were an achievement worthy of note yet were overshadowed by the brilliant sculptures contained within. Here, they can have the spotlight for a few pages. The sand wall was Yousef's idea. He was the producer and the mastermind of this event. Ted and I pushed back on the concept at first. We didn't believe it was a wise use of resources in an already resource-demanding project. However, if we were successful, it would be a first of its kind, and it would make a clean backdrop to the sculptures. So, we agreed to include the idea into the plans.

I began the engineering process and designed a wall-forming system. It had a mid-tower and end-cap design that would re-use a single set of forms. The towers added architectural interest and structural integrity to the entire wall structure. A group of forms could cast the wall in sequential and connected sections. The walls and towers also needed Arabian-style crenelations. This level of detail added even more to the challenge. Hundreds of crenelations would be a time disaster if each one needed to be sculpted. We couldn't afford to have sculptors working on this detail. The crenelations needed to be cast and not carved. Dennis Storlie led the charge and had a simple one-piece form design. Brian was convinced that his design, which came apart for easy release, was the best method. Unwilling to concede with words alone, I called for a competition. Dennis and Brian prepared their forms, the starting horn went off, and the race was on. Dennis made three crenelations before Brian finished one. Dennis was once again free to lead the charge.

The walls were progressing, and didn't need my attention for a while. There were bigger fish to fry. Not creative fish, but daily details like securing drinking water for 70 artists. Despite my negotiations for a week's worth of drinking water supply, only a day's worth would be delivered each morning. Not even enough for one day. This meant some artists were left thirsty at the end of working in the hot Kuwait sun. Water shortages led to hoarding and stashing, leaving even more artists thirsty. I digress. Let us return to the wall.

Barry was hired as a machine operator. He was also a sculptor, so it was a useful combination and was the reason he was brought on to the project. He was working with the wall crew operating a front-end loader, but it turned out to be too technical for his skill level. These walls were precise and were being built in tight

Dennis Storlie releases a crenelation from his form.

The amount of work left to do was daunting. She suggested we get everyone to stop working on their sculptures for a day and help with the walls. I didn't respond to her idea immediately.

spaces surrounded by other sculptures in progress. I had to pull him off the machine but kept him on the wall crew. The plan was for the walls to be formed with no finishing required. The pressure from compacting sand prevented the forms from lining up perfectly. Once the forms were removed, a stepped and uneven surface was left on the walls. They all needed hand finishing to smooth them out. This is how Barry landed that job.

The project was pressing forward after the low point of the storm. We were back on track, logistics had improved, the damaged sculptures had been repaired, and new ones emerged from the sand. I was feeling confident. As I hung my elbow out the truck window and chatted with a technician about logistics the sculptor Nicola approached. She thought the small team working on the walls were suffering a tough gruel. The amount of work left to do was daunting. She suggested we get the artists to stop working on their sculptures and help with the walls for a day. I didn't respond to her idea immediately. With over seventy sand sculpting experts on the project, I received criticism often. So much was going wrong, or "off-plan," but we hid it from the artists so they didn't fully understand some of the decisions happening around them. I had developed a thick skin because of this, so the idea just bounced off of me at first. In the evening, I realized it might be a good idea. I put out the call to the sculptors, and many volunteered. It was beyond my expectations. It wasn't just a good idea, it was a brilliant idea! We finished massive lengths of the wall that day, boosting our morale and camaraderie. It was a turning point for the entire project.

Sculptor - Barry Swires

ARABIAN NIGHTS ~ SCULPTURE PARK MAP

Part IV

To save himself, he climbed up a large tree and hid where he could see all that passed. Sculptors - Igor Akimov & Egor Ustyuzhanin

Ali Baba and the Forty Thieves

There lived two brothers, one named Cassim and the other Ali Baba. Cassim married a widow who became heiress to a large estate and a shop full of rich merchandise. Cassim became one of the richest merchants and lived at ease. On the other hand, Ali Baba married a woman as poor as himself and had no other means of maintaining his wife and children than his daily labor of cutting wood and bringing it upon three donkeys into town to sell. One day, when Ali Baba was in the forest, he saw a great cloud of dust at a distance and distinguished a large body of horses coming briskly on and thought, they might be robbers. To save himself, he climbed up a large tree and hid where he could see all that passed. This tree stood at the bottom of a single rock, which was very high and steep. The well-armed troop came to the foot of this rock and dismounted. Ali Baba counted forty of them and, by their looks, never doubted that they were thieves and made this place their rendezvous. One, whom he took to be their captain, came to the face of the rock and pronounced the words: "Open, Sesame!" A door opened, and after he had made his entire troop go in before him, he followed, and the door shut. Ali Baba sat patiently in the tree. At last, the door opened again, and the forty thieves came out. Ali Baba heard the captain close the door, pronouncing, "Shut, Sesame." Every man mounted his horse, and they returned the way they came. Ali Baba waited a while and then he came down. Remembering the captain's words, he stood before the rock and said, "Open Sesame." The door instantly flew open. Ali Baba, who expected a dark, dismal place, was surprised to see it spacious and well-lit, receiving the light from an opening at the top of the rock. He saw rich bales of merchandise. Silk, brocade, valuable carpeting, gold and silver lay in great heaps, and money in large leather purses. Ali Baba went immediately into the cave, and the door shut as soon as he was inside. But this did not disturb him because he knew the secret of reopening it. He made the

One day, when Ali Baba was in the forest, he saw a great cloud of dust at a distance and distinguished a large body of horses coming briskly on; and thought they might be robbers. Sculptors - Dmitry Klimenko & Ivan Zverev

One, whom he took to be their captain, came to the face of the rock and pronounced these words, "Open, Sesame!" A door opened, and after he had made his entire troop go in before him, he followed, and the door shut.

He made the best use of his time in carrying out as much of the gold coin as he thought his three asses could carry. He loaded them with the bags and laid the wood on them so curious eyes could not see them.

best use of his time in carrying out as much of the gold coin as he thought his three asses could carry. He loaded them with the bags and laid the wood on them so curious eyes could not see them. He then made his way to the town.

When Ali Baba got home, he carried the bags into his house and arranged them before his wife. She found them full of money and suspected that her husband had been stealing, saying, "Ali Baba, have you been so unhappy as to----" "Be quiet," interrupted Ali Baba, "I am no robber unless one can steal from robbers." Then he emptied the bags, which raised such a great heap of gold that it dazzled his wife. He told her the whole adventure from beginning to end and told her to keep it secret. The wife rejoiced with her husband. Ali Baba said, "I will go and dig a hole and bury it." Ali Baba's wife wanted to count the gold. "Let us know how much we have. I will borrow a small measure from my brother-in-law Cassim and weigh it while you dig the hole." The wife ran to her brother-in-law but found his wife in his place. She asked her to lend her a measure. The sister-in-law did so, but as she knew Ali Baba's poverty very well, she was suspicious of what his wife wanted to measure and artfully put some suet at the bottom of the measure. Ali Baba's wife went home and measured the gold heap until she was done. While Ali Baba was burying the gold, his wife carried the measure back without noticing the piece of gold stuck to the bottom. Cassim's wife looked at the bottom of the measure and was inexpressibly surprised to find the gold sticking to it. Envy immediately possessed her heart.

Ali Baba, who expected a dark, dismal place, was surprised to see it spacious and well-lit, receiving the light from an opening at the top of the rock. Sculptors - Daniel Doyle, Fergus Mulvany & Kirk Rademaker

When Cassim came home, his wife said, "Cassim, you think yourself rich, but you are mistaken. Ali Baba is infinitely richer than you! He does not count his money, but he weighs it!" Cassim asked her to explain the riddle, which she did. Instead of being pleased with his brother's prosperity, Cassim could not sleep that night and visited Ali Baba before sunrise. "You pretend to be miserably poor, and yet you weigh your gold!" Cassim said. "What, brother?" Replied Ali Baba; "I do not know what you mean" "Do not pretend ignorance," replied Cassim, showing him the piece of gold his wife had given him. "How many of these pieces have you? My wife found this at the bottom of the measure you borrowed yesterday." Without showing the slightest surprise, Ali Baba confessed all and offered him part of his treasure to keep the secret. Cassim replied, "I will know exactly where this treasure is and the signs and tokens by which I may go to it myself! Otherwise, I will go and inform against you." Ali Baba, more out of his natural good temper than fear, told him all he desired and even the words he was to use to go into the cave and come out again.

Cassim rose early the following day and set out with ten mules laden with great chests. It was not long before he came to the rock. He pronounced the words, "'Open, Sesame,'" and it opened. When he was in, it shut again. He was astonished to find much more riches than he had supposed from Ali Baba's story. He laid as many bags of gold as he could carry away by the entrance, and, coming to open the door, his thoughts were so full of the great riches that he could not think of the magic word. He named several sorts of grain, all but the right one, so the door would not open. At noon the robbers returned to their cave and, from some distance, saw Cassim's mules straggling about the rock with great chests on their backs. Alarmed, they galloped

at full speed. The captain and the rest went straight to the door with drawn sabers in their hands, and on their pronouncing the words, it opened. Cassim saw the door open and jumped out but could not escape the robbers. With their sabers, they soon deprived him of life. None of them could imagine which way he entered. They were all positive that nobody knew their secret. They agreed, therefore, to cut Cassim's body into four quarters and hang him inside the cave door to terrify any person who might attempt the same thing.

Cassim's wife was very uneasy when her husband had not returned. She ran to Ali Baba and said, "I believe your brother is gone to the forest, and he has not returned. I am afraid some misfortune has befallen him." Ali Baba went immediately with his three donkeys. He went to the forest, and when he came near the rock, he was surprised to see blood by the door. Ali Baba pronounced the words, the door opened, and there was the dismal sight of his brother in quarters. He went into the cave to gather the remains, put them on one of his donkeys, and covered them with wood. The other two donkeys he loaded with bags of gold and came home to his sister-in-law's. Ali Baba knocked at the door. Morgiana, a slave, opened. When he entered the court, He unloaded the donkeys and, taking Morgiana aside, said to her, "The first thing I ask of you is secrecy. Your master's body is hidden in these two bundles, and our business is to bury him as if he had died a natural death. Go and tell your mistress I want to speak to her."

Ali Baba told his sister all about his journey till he came to the finding of Cassim's body. "Now, sister, we must act like my brother has died a natural death." Morgiana went to an apothecary and asked for medicine to cure the most dangerous illnesses. The apothecary asked her who was ill. She replied, "My good master Cassim himself. He could neither eat nor speak."

Ali Baba and his wife were often seen going between Cassim's and their own house all that day and appeared melancholy. Nobody was surprised to hear the shrieks and cries of Cassim's wife and Morgiana, who told everyone that her master was dead. The Next morning, Morgiana, who knew an old cobbler, went to him and put a piece of gold into his hand. "Well," said Baba Mustapha, looking at the gold, "this is good handling. What must I do for it?" "You must take your sewing tackle and go with me blindfolded." Baba Mustapha said, "you would have me do something against my conscience or my honor?" "Nay," said Morgiana, putting another piece of gold into his hand, "only come along with me and fear nothing." Baba Mustapha went with Morgiana and never unbandaged his eyes until he arrived. "Baba Mustapha, you must make haste and sew these pieces of my master together, and when you have done, I will give you another piece of gold." After Baba Mustapha had done this, she led him back to where she first bound his eyes and then went home. In this manner, they concealed Cassim's death so nobody in the city had the slightest suspicion. Three or four days after the funeral, Ali Baba moved his few goods to his brother's widow's house, and soon afterward, the marriage with his sister-in-law was published.

Let us return to the forty thieves. They came again to visit their retreat in the forest, surprised to find Cassim's body taken away as well as some of their gold! "We have been discovered." Said the captain. "This plainly shows that he had an accomplice. We must look for the other. What say you, my lads?" The robbers agreed they must lay all other enterprises aside until they found the accomplice. "First, one of you who is bold must go into the town dressed like a traveler and find out who he is and where he lives." One of the robbers volunteered and went into the town at daybreak. He walked until he came to Baba Mustapha's stall, which was always open before any of the shops in the town. The robber saluted him and said, "You begin work very early. Is it possible that one your age can see so well?" "Certainly," replied Baba Mustapha, "old as I am, I have perfect eyes, and you will not doubt it when I tell you that I sewed a dead man together when I had not so much light as I have now." The robber was overjoyed to think he had the information he wanted without being asked. The robber pulled out a piece of gold and, putting it into Baba Mustapha's hand, said, "The only thing which I request of you is to do me a favor to point out the house where you stitched up the dead man." Baba Mustapha said, "I assure you I cannot. They first

They agreed, therefore, to cut Cassim's body into four quarters and hang him inside the cave door to terrify any person who might attempt the same thing.

"First, one of you who is bold must go into the town dressed like a traveler and find out who he is and where he lives." One of the robbers volunteered and went into the town at daybreak.

blindfolded me and then led me to the house and brought me back again in the same manner." "Perhaps you may remember some part, and as everybody ought to be paid for their trouble, there is another piece of gold for you." The two pieces of gold were a great temptation. He pulled out his purse and put them in. "I cannot assure you that I remember the way exactly, but since you desire it, I will try." He led the robber directly opposite Cassim's house, where Ali Baba lived now, upon which the thief marked the door with a piece of chalk. The robber, finding he could discover no more from Baba Mustapha, returned to the forest.

Morgiana went out of Ali Baba's house for a time and, coming home again, saw the mark the robber had made. "Either somebody intends my master no good, or else some boy has been playing the rogue." She fetched a piece of chalk and marked two or three doors on each side in the same manner. The thief rejoined his troop and told them about his success. The captain said, "Comrades, let us all set off well armed, without its appearing who we are and find out the house." The robber led the captain into the street where he had marked Ali Baba's house, and when they came to one of the houses which Morgiana had marked, he pointed it out. But going a little further, the captain observed that the next door was chalked and saw five or six houses all marked in the same manner. The robber assured the captain

that he had marked but one and could not tell who had chalked the rest. All declared the robber worthy of death, and so was done. Another of the gang promised that he would succeed better. He corrupted Baba Mustapha, as the other had done, and being shown the house, he marked it, in a place more out of sight, with red chalk. Morgiana, whose eyes nothing could escape, saw the red chalk and marked the neighbors' houses in the same place and manner. On his return to his company, the robber prided himself on the precaution he had taken. They traveled to the town, and when they came to the street, they found the same difficulty. The captain was enraged at the robber, and he underwent the same punishment. Having lost two of his troops, the captain resolved to take this vital mission upon himself. He went to Baba Mustapha, who did him the same service he had done to the former men. By passing and re-passing, he scrutinized the house so he couldn't mistake it. The captain returned to the forest and ordered his troop to buy nineteen mules and thirty-eight large leather jars, one full and the others all empty. The captain put one of his men into each and rubbed the jars on the outside with oil. The captain reached the town by dusk with the nineteen mules loaded with thirty-seven robbers in pots and the pot of oil. Ali Baba was sitting outside to take a little fresh air. The robber said, "I have brought some oil here to sell at tomorrow's market, and it is now so late that I do not know where to lodge. Do me a favor to let me pass the night here, and I shall be very much obliged to you." He told him he would be welcome and immediately opened his gates for the mules to enter the yard. He then went to

All declared the robber worthy of death, and so was done. Another of the gang promised that he would succeed better.
Sculptors - Dmitry Klimenko & Ivan Zverev

Morgiana to bid her hot supper for his guest. The captain ordered, "As soon as I throw some stones out of my window, do not fail to cut open the jar with the knife and come out." After this, he returned to the kitchen, and Morgiana, taking a light, conducted him to his chamber. Morgiana, remembering Ali Baba's orders to get his bathing linen ready, ordered the other servant to set on the pot for the broth, but the lamp went out, and there was no more oil in the house. So she took the oil pot and went into the yard to fetch some from the merchant's jars. As she approached the first jar, the robber within said softly, "Is it time?" The voice struck Morgiana; she immediately

Being shown the house, he marked it, in a place more out of sight, with red chalk. Sculptors - Peter Vogelaar & Lucinda Wierenga "Sandy Feet"

sensed the importance of keeping the danger a secret. She collected herself and answered, "Not yet, but presently." She went this way to all the jars, giving the same answer until she came to the jar of oil. She hurriedly filled her oil pot, returned to the kitchen, took a great kettle, and went again to the oil jar. She filled the kettle and set it on a great wood fire to boil. She then poured enough boiling oil into every jar to destroy the robber within. She remained silent, resolving not to go to bed till she observed what was to follow through a kitchen window that opened into the yard. She had not waited long before the captain of the robbers gave the signal by throwing little stones. Not hearing or perceiving anything, he threw stones again a second and third time. Much alarmed, he went into the yard and examining all the jars one

Morgiana went out of Ali Baba's house for a time and, coming home again, saw the mark the robber had made. "Either somebody intends my master no good, or else some boy has been playing the rogue."

She filled the kettle and set it on a great wood fire to boil. She then poured enough boiling oil into every jar to destroy the robber within. Sculptors - Pedro Mira & Kirk Rademaker

after another, he found that all his gang was dead. Enraged at failing, he fled from the yard, climbing over the walls, and escaped.

When the sun had risen, Ali Baba was surprised to see the oil jars and the merchant had gone. He asked Morgiana the reason for it. She bade him look into the first jar. Ali Baba did so and, seeing a man, started back frightened. Ali Baba examined all the other pots and stood for some time motionless. At last, when he had recovered himself, he said, "And what has become of the merchant?" Morgiana replied, 'Merchant! He is as much one as I am. I was suspicious of him two or three days before but did not think it necessary to acquaint you with it. I found our street door marked with white chalk and the next morning with red. I marked two or three neighbors' doors on each side in the same manner. If you reflect on this and

Much alarmed, he went into the yard and examining all the jars one after another, he found that all his gang was dead.

166

Morgiana dressed like a dancer girded her waist with a silver-gilt girdle, and put a mask on her face. "Come in, Morgiana," said Ali Baba, "and let Cogia Houssain see what you can do." Sculptors - Calixto Molina & Rogelio Evangelista

what has happened since you will see it to be a plot of the robbers." Ali Baba was so impressed with the service she had done him that he said to her, "I owe my life to you, and I give you your liberty from this moment!"

The captain of the forty thieves returned to the forest, mortified. He hid in the cave and hatched a new plan for revenge. He disguised himself again, went to the town, and he took a furnished shop, which happened to be opposite Cassim's, which Ali Baba's son had occupied. He took the name of Cogia Houssain and was highly civil to all the merchants, his neighbors, and especially Ali Baba's son. He cultivated a friendship. Ali Baba's son did not care to lie under such obligations to Cogia Houssain without making a like return. He, therefore, told his father, Ali Baba. Ali Baba told his son to invite him over for dinner. Ali Baba received Cogia Houssain and thanked him for all the favors he had done his son, adding that the obligation was more outstanding. Ali Baba went into the kitchen and asked Morgiana to prepare dinner. Morgiana was carrying out the dishes, looked at Cogia Houssain, and knew him

to be the captain of the robbers. She noticed that he had a dagger hidden under his garment. Instead of going to supper, Morgiana dressed like a dancer, girded her waist with a silver-gilt girdle, and put a mask on her face. "Come in, Morgiana," said Ali Baba, "and let Cogia Houssain see what you can do." After she had danced several dances, she drew the knife in a concealed manner. Cogia Houssain, seeing that she was coming to him, pulled out his purse to give her a present. While putting his hand into it, Morgiana plunged the knife into his heart. Ali Baba and his son cried, "What have you done?" "It was to preserve you, not to ruin you." Answered Morgiana, "For see here!" She opened Cogia Houssain's garment showing the dagger, "Look well at him, and you will find him to be the captain of the gang of forty thieves." Ali Baba immediately felt his new obligation to Morgiana for saving his life a second time. "Morgiana, I gave you your liberty, and my gratitude shall not stop there. The time has come for me to make you my daughter-in-law." Then he told his son, "You will not refuse Morgiana for your wife." The son readily consented to the marriage, not only because he would obey his father but because he loved Morgiana for herself. Ali Baba celebrated the wedding of his son and Morgiana with great splendor. His family used their good fortune with moderation, lived in great honor and majesty, and filled the highest offices of the city.

"For see here!" She opened Cogia Houssain's garment showing the dagger, "Look well at him, and you will find him to be the captain of the gang of forty thieves." Sculptors - Dmitry Klimenko & Ivan Zverev

Fergus Mulvany puts to final touches to this unique sand sculpture. At night the floor was a mist of dry ice and lights illuminated the hidden elements scattered within the cave helping the patient viewer to discover them.

170

Sinbad the Sailor and Sinbad the Porter

One day, Sinbad the Porter, who carried burdens on his head for hire, sat on a bench to rest at a merchant's house. He heard music and joy and excited voices. He went to the gate to see a train of servants that would fit a Sultan. He started reciting some verses and was about to proceed when a foot page stopped him. His lord wanted to speak with him, Sinbad was reluctant to go, but the foot page insisted. In the house, he saw so many things that would resemble a king's palace. He stood before the master of the house with a humble attitude. The master said he was also called Sinbad, just like the porter. Sinbad the Sailor. He asks the porter to recite the verses again. Sinbad the Sailor took a liking to the porter and said he would tell the story of how he got his riches on his seven voyages. Sinbad began, "These are my adventures...."

The master said he was also called Sinbad, just like the porter.
Sculptor - Katsuhiko Chaen

The First Voyage

Who seeks fame without toil and strife / The impossible seeks and wastes life." So I found a ship, a good captain and crew, and went sailing in search of adventure and treasures. Sculptors - Maxim Gazendam & Jeroen Advocaat

Sculptors - Alexsey Samolov, Aleksandr Skarednov, Denis Bespalov, Egor Ustyuzhanin, Igor Akimov, Brian Turnbough & Max Bespalov

The ship's Captain screamed at us to come back because we were not on an island but on the back of a giant whale!

When I was a child, I was left with great wealth by my deceased father. I grew up in luxury, but in the end, I squandered my wealth until it was mostly gone. I decided to buy the goods needed for a voyage because: "Who seeks fame without toil and strife / The impossible seeks and wastes life." So I found a ship, a good captain and crew, and went sailing in search of adventure and treasures.

Upon our first voyage, we came to an island that looked so inviting that my crew and I took to the shore. We lit fires during our camp which seemed to stir the ground beneith us. The ship's Captain screamed at us to come back because we were not on an island but on the back of a giant whale! Those nearest to the boat threw themselves into it, and others sprang into the sea. The whale plunged suddenly into the ocean's depths, leaving me clinging to a piece of the wood we had brought to make our fire.

The currents took me to the shore of an island. After some days and nights of eating fruit and resting under the trees, I saw a horse in the

176

Those nearest to the boat threw themselves into it, and others sprang into the sea. Sculptor - Aleksandr Skarednov

distance. When I drew near, the horse screamed at me. A man appeared who calmed him down. He saw me, and after a brief exchange, he took me into an underground chamber, where I learned more men like him were the grooms of King Mihrjan, and they keep his horses. With every full moon, they brought the mares to the beach, and out from the sea would come stallions who did their will with the mares. The mares conceived colts and fillies of which none is found their like. Their leader offered to show me their country and its King. We went to the King, and I related my story. The King decided then to make me an agent for the port and registrar of the ships. I spoke to many of the merchants, travelers, and sailors of the city of Baghdad and grew weary.

One day a ship arrived with cargo belonging to a merchant called Sinbad. I told them that I was the merchant Sinbad! The merchants did not believe me at once. After I related the details of my travels the merchants eventually believed me. I went to King Mihrjan and gave him a present for his hospitality, sold my goods, bought new ones, and set sail to Baghdad, where I became wealthy from trading my cargo.

They brought the mares to the beach and out from the sea would come stallions who did their will with the mares.

One day a ship arrived with cargo belonging to a merchant called Sinbad. I told them that I was the merchant Sinbad! The merchants did not believe me at once. Sculptors - Brian Turnbough, Aleksandr Skarednov & Greg Jacklin

The Second Voyage

As I wandered about, seeking anxiously for some means of escaping this trap, I observed that the ground was strewed with diamonds.

I craved to travel again, so I found a ship and crew and set sail. One day we came to an island for a rest where the ship's crew accidentally abandoned me. I searched the shore but could not find anyone or anything. I climbed the tallest tree and could observe my ship sailing away. Knowing there was no hope for a rescue, I turned landward, and my curiosity was excited by a huge dazzling white object so far off that I could not determine what it might be. I set off as fast as I could toward it. It seemed to be a white ball of immense size and height, I walked around it, seeking some opening, but there was none. It was at least fifty paces around. Then I remembered I had heard the sailors speak of a giant bird called a roc. The white object must be its egg! Sure enough, one of the birds settled slowly down upon it, covering it with its wings to keep it warm. I cowered close beside the egg. One of the bird's feet, which was as large as the trunk of a tree, was just in front of me. Taking off my turban, I bound myself securely to it, hoping the roc would take me away from the desolate island when it took flight. My plan worked, and this was precisely what happened.

Then I remembered I had heard the sailors speak of a giant bird called a roc. The white object must be its egg!
Sculptors - Calixto Molina, Paulina Siniatkina, Rogelio Evangelista.

When I became aware that the roc had settled and that I was once again upon solid ground, I hastily freed myself, and not a moment too soon. Sculptor - Calixto Molina

When I became aware that the roc had settled and that I was once again upon solid ground, I hastily freed myself, and not a moment too soon; for the bird, pouncing upon a giant snake, killed it with a few blows and rose into the sky. When I looked about me, I began to doubt if I had gained anything by leaving the island.

The valley in which I found myself was deep, narrow, and surrounded by mountains that towered into the clouds and were so steep and rocky that there was no way of climbing up their sides. As I wandered about, seeking anxiously for some means of escaping this trap, I observed that the ground was strewn with diamonds, some astonishingly large. This sight gave me great pleasure, but my delight was speedily dampened when I saw snakes so long and large that the smallest could have easily swallowed an elephant. Fortunately for me, they seemed to hide in caverns of the rocks by day and only came out by night, probably because of their enemy, the roc.

I crept into a little cave and blocked its entrance with a stone. Throughout the night, the serpents crawled to and fro, hissing horribly so

that I could scarcely close my eyes for terror. I was thankful when the morning light appeared. When I judged by the silence that the serpents had retreated to their dens, I came tremblingly out of my cave. I sat down on a rock when I was startled by something falling to the ground with a loud thud beside me. It was a massive piece of fresh meat. I thought of the stories the sailors told of the famous valley of diamonds and the cunning way some merchants devised to get at the precious stones. The merchants threw great lumps of meat into the valley. These fell with so much force upon the diamonds that when the eagles carried them off to their nests to feed their young, they would take some diamonds with them. Then the merchants would secure their treasures, scaring away the birds. This was my way out. With the aid of my turban, I found the largest diamond and bound a piece of meat firmly to my back. One of them seized upon my meat and me with it. When the roc dropped me, the merchants rushed to the nest, scaring away the bird. They were disappointed to find me and abused me for having robbed them of their usual profit. I said, "I am sure if you knew all that I have suffered, you would show more kindness towards me, and as for diamonds, I have enough here for you too." They assured me they had seen no stones like the ones I gave them in all their years harvesting them.

I accompanied them on their journey home, passing through high mountains infested with frightful serpents, but we had good luck escaping them and finally came to the seashore. We sailed home, and I profited greatly on our homeward way. At last, we reached Balsora, whence I hastened to Baghdad. There my first action was to bestow large sums of money upon the poor, after which I settled down to enjoy the tranquility and the riches I had gained with so much toil and pain.

Throughout the night, the serpents crawled to and fro, hissing horribly so that I could scarcely close my eyes for terror. Sculptor - Joris Kivits

The Third Voyage

The door violently burst open, and a horrible giant entered. He was as tall as a palm tree, perfectly black, and had one eye flaming like a burning coal in the middle of his forehead. Sculptor - Benjamin Probanza

He slept as before. When we heard him begin to snore, I, and nine of the boldest of my comrades, rose softly, and each took a spit, which we made red-hot in the fire, and then at a given signal, we plunged them into the giant's eye.
Sculptors - Jihoon Choi & Tae-in Kim

After a short time enjoying an easy life, I grew bored and set sail with other merchants for distant lands. One day upon the open sea, we got caught in a terrible wind that blew us entirely out of our reckoning and, lasting for several days, finally drove us into the harbor on a strange island. There appeared a vast multitude of hideous savages, not more than two feet high and covered with reddish fur. Throwing themselves into the waves, they surrounded our vessel. They swarmed up the ship's side with such speed and agility that they almost seemed to fly. They stole our vessel and sailed off, leaving us helpless on the shore.

Turning away from the sea, we wandered miserably inland. We saw in the far distance what seemed to be a splendid palace. When we reached it we saw it was a lofty and strongly built castle. Pushing back the heavy ebony doors, we entered the courtyard. On one side lay a huge pile of human bones, and on the other, large spits for roasting. The door violently burst open, and a horrible giant entered. He was as tall as a palm tree, perfectly black, and had one eye flaming like a burning coal in the middle of his forehead. His teeth were long and sharp, and he grinned horribly while his lower lip hung down upon his chest, and he had ears like elephant's ears, which covered his shoulders, and nails like the claws of some fierce bird. The giant sat examining us attentively with his fearful eye. He came towards us and stretched out his hand to take me by the back of my neck and examine me up close. Feeling that I was mere skin and bone, he set me down and went on to the next. He treated them in the same fashion. At last,

he came to the captain and, finding him the fattest of us all, took him, stuck him upon a spit, and proceeded to kindle a huge fire and roasted him. After the giant had supper, he lay down to sleep, snoring like the loudest thunder, while we lay shivering with horror the whole night through, and when day broke, he awoke and went out, leaving us in the castle.

We escaped and spent the day building rafts, each capable of carrying three persons. We returned to the castle at nightfall, and soon after, the giant returned, and one more of our number was sacrificed. The time of our vengeance was at hand! As soon as he finished his horrible roast, he slept as before. When we heard him begin to snore, I and nine of the boldest of my comrades rose softly, and each took a spit, which we made red-hot in the fire, and then at a given signal, we plunged them into the giant's eye, completely blinding him. Uttering a terrible cry, he sprang to his feet, clutching in all directions to try and seize one of us. After a vain search, he fumbled about till he found the door and fled out of it howling. Hesitating no longer, we clambered upon our rafts and rowed with all our might out to sea. Seeing their prey escaping them, the other giants seized up huge pieces of rock and, wading into the water, hurled them at us with such good aim that all the rafts but mine sunk. Rowing hard, we at last gained the open sea. Here we were at the mercy of the winds and waves, which tossed us to and fro all that day and night. The next morning we found ourselves near an island, upon which we gladly landed.

There we found delicious fruits and satisfied our hunger. We laid down to rest upon the shore when suddenly we were aroused by a loud rustling noise. Starting up, we saw an immense snake gliding toward us over the sand. So swiftly it came, it seized one of my comrades before he had time to fly. Seeing a tall tree, we climbed up into it, first providing ourselves with a store of fruit off the surrounding bushes. Stuck in the

Uttering a terrible cry, he sprang to his feet, clutching in all directions to try and seize one of us.
Sculptor - Sue McGrew

tree, the snake managed to eat my comrades. Finally, I escaped and crawled down to the sea, feeling that it would be better to plunge from the cliffs and end my life at once than pass such another night of horror. I saw a ship sailing by, and by shouting wildly and waving my turban, I managed to attract the attention of her crew. I found myself on board surrounded by a wondering crowd of sailors and merchants. After sailing for some time, we came to the island of Salahat, where sandalwood grows in great abundance. Here we anchored, and I stood watching the merchants disembarking their goods and preparing to sell or exchange them. The captain approached me and said, "I have some merchandise belonging to a dead passenger of mine. Will you do me the favor to trade with it, and when I meet with his heirs, I shall be able to give them the money." He sent for

Seeing their prey escaping them, the other giants seized up huge pieces of rock and, wading into the water, hurled them at us with such good aim that all the rafts but mine sunk. Sculptors - Sue McGrew & Andrius Petkus

the person whose duty was to keep a list of the goods on the ship. When this man came, he asked in what name the merchandise was to be registered. "In the name of Sinbad the Sailor," replied the captain. "So, captain," said I, "the merchant who owned those bales was called Sinbad?" "Yes," he replied. "By mischance, he was left behind upon a desert island, and it was not until it was too late that it was realized." "Why, captain!" I cried, "Look well at me. I am that Sinbad who fell asleep upon the island and awoke to find himself abandoned!" The captain stared at me in amazement and rejoiced greatly at my escape. So I returned to Baghdad with so much money that I could not count it. I gave largely to the poor and bought land to add to what I already possessed, and thus ended my third voyage.

The Fourth Voyage

After some time we got caught in a violent hurricane and our vessel became a total wreck. Many of our company perished in the waves. Sculptor - Bouke Atema

Prosperous and happy as I was after my third voyage, I could not decide to stay at home altogether. I took a ship at a distant seaport and, after some time, got caught in a violent hurricane, and our vessel became a total wreck. Many of our company perished in the waves. With a few others, I had the good fortune to be washed ashore by clinging to pieces of the wreck. At daylight, we wandered inland and soon saw some huts. As we drew near, their inhabitants swarmed and surrounded us in great numbers. They took me and five others into a hut, making us sit on the ground. Certain herbs were given to us, which the natives made signs for us to eat. Observing that they did not touch them, I only pretended to taste my portion. My companions, being very hungry, rashly ate up all that was set before them. The savages now produced large bowls of rice prepared with coconut oil, which my crazy comrades ate eagerly. Still, I only tasted a few grains, understanding clearly that the object of our captors was to fatten us for their eating. My companions were soon fat, and there was an end to them, but I grew leaner every day. As I was so far from being a tempting morsel, I was allowed to wander about freely, so I managed to escape and plunged into the forest. For seven days, I hurried on until I reached the seashore and saw a party of men gathering pepper. I advanced toward them, and they greeted me in Arabic. I willingly satisfied their curiosity, telling them how I had been shipwrecked and captured by the cannibals. They took me back to their own country and presented me to their king, who received me with hospitality. I soon began to feel at home and content. The king treated me with special favor, and I soon became wealthy and important in the city.

One day the king sent for me and said, "Sinbad, I desire that you marry a rich and beautiful lady whom I will find for you and think no more of your own country." I accepted the charming bride he presented to me and lived happily with her. Nevertheless, I had every intention of escaping at the first opportunity. Things were going prosperously with me when my neighbor's wife died. I went to his house to offer my consolation and found him in the depths of woe. "I have but an hour left to live!" "Come, come!" Said I, "surely it is not so bad." "I have set my house in order, and today I shall be buried with my wife. This has been the law upon our island. The living husband goes to the grave with his dead wife, the living wife with her dead husband." They buried the wife with the husband down into the depths of a horrible cavern. Then, a stone was pushed over the opening, and the melancholy company wound its way back to the city. I was so horrified that I could not help telling the king how it struck me. "Your Majesty," said I, "dare I ask if this law applies to foreigners also?" "Why, yes," replied the king smiling, in what I could but consider a heartless manner, "there are no exceptions." Sure enough, before long, my wife fell ill and, in a few days, breathed her last breath.

My dismay was great, for there was no escape. The body of my wife, arrayed in her richest robes, was laid upon the bier. I followed it, and after me came a grand procession headed by the king and all his nobles. In this order, we reached the fatal mountain. I was lowered into the gloomy pit with seven loaves and a pitcher of water beside me. Before I reached the bottom, the stone was pushed into place, leaving me to my fate. I could see that I was in a vast vault, bestrewn with bones and bodies of the dead. I even fancied that I heard

I was lowered into the gloomy pit with seven loaves and a pitcher of water beside me. Before I reached the bottom, the stone was pushed into place, leaving me to my fate. Sculptors - Guy-Olivier Deveau & Nicola Wood

the expiring sighs of those who had come into this dismal place alive like myself.

I lived in darkness and misery until my provisions were almost exhausted when I heard something that breathed loudly. Turning to the place from which the sound came from I dimly saw a shadowy form that fled at my movement, squeezing itself through a cranny in the wall. I pursued it as fast as I could and found myself in a narrow crack among the rocks, along which I was just able to force my way. I followed it for what seemed to me many miles and, at last, saw a glimmer of light that grew clearer. I emerged upon the seashore with a joy that I cannot describe. I returned to the cavern and amassed a rich treasure of diamonds, rubies, emeralds, and jewels that strewed the ground. I then waited hopefully for the passing of a ship. One came, and in answer to the sailors' questions about how I came to be in such a plight, I replied that I had been shipwrecked two days before but had managed to scramble ashore with the treasure. They believed my story, took my bundles, and rowed me back to the ship. I found myself in Baghdad once more with unheard-of riches of every description. Again, I gave large sums of money to the poor and enriched all the mosques in the city.

The Fifth Voyage

Despite all I could say to deter them, the merchants with me fell upon it with their hatchets, breaking the shell and killing the young roc. Sculptors - Greg J Grady & Pedro Mira

Not even all I had gone through could make me contented with a quiet life. Therefore, I set out once more, and after a long voyage upon the open seas, we landed on an unknown island that proved uninhabited. We had not gone far when we found a roc's egg, as large as the one I had seen before and very nearly hatched, for the beak of the young bird had already pierced the shell. Despite all I could say to deter them, the merchants with me fell upon it with their hatchets, breaking the shell and killing the young roc. Then lighting a fire upon the ground, they hacked morsels from the bird and roasted them while I stood aghast. Scarcely had they finished their ill-omened meal when two mighty shadows darkened the air above us. Knowing by experience what this meant, the captain of my ship cried out that the parent birds were coming. He urged us to get on board with all speed, and this we did. The sails were hoisted, and we thought we had escaped. The rocs soared into the air directly over our vessel and each held an immense rock in its claws. The captain skillfully dodged a few, but before long, a rock fell with a mighty crash in the midst of our vessel, smashing it into a thousand fragments and hurling the passengers and crew into the sea. I was unhurt, and by holding on to a piece of driftwood, I kept myself afloat and washed up on an island. It seemed to me that I had reached a garden of delights. There were trees everywhere, laden with flowers and fruit, while a crystal stream wandered in and out under their shadow. Then I saw an old man bent and feeble sitting upon the river bank, and at first, I took him to be some ship-wrecked mariner like myself. Going up to him, I greeted him in a friendly way, but he only made signs to me that he wished to get across the river to gather some fruit and seemed to beg me to carry him on my back. Pitying his age and feebleness, I took him up, and wading across the stream, I bent down so that he might more easily reach the bank and bade him get down. But instead of

Then lighting a fire upon the ground, they hacked morsels from the bird and roasted them while I stood aghast.
Sculptor - Yosef Bakir

Each held an immense rock in its claws. The captain skillfully dodged a few, but before long, a rock fell with a mighty crash in the midst of our vessel. Sculptor - Andrius Petkus

standing upon his feet, his legs gripped me so tightly that I was nearly choked, and I fell insensible to the ground. When I recovered, my enemy was still on my back, and seeing me revive, he prodded me and forced me to get up and stagger about with him under the trees while he gathered and ate the choicest fruits. This went on all day and even at night. The terrible old man held tight to my neck even when I threw myself down half-dead with weariness. One day, I passed a tree under which lay several dry gourds, and catching one up, I amused myself with scooping out its contents and pressing into it the juice of several bunches of grapes that hung from every bush. When it was full, I left it propped in the fork of a tree, and a few days later, carrying the hateful old man that way, he stretched out his skinny hand and seized the gourd. First, he tasted its contents cautiously, then drained them to the last drop. The wine was strong and the gourd capacious, so he also began to sing after a fashion, and soon I had the delight of feeling the iron grip of his legs unclasp, and with one vigorous effort, I threw him to the ground, from which he never moved again. By the most extraordinary luck, I met with some mariners who had anchored off the island. They heard the story of my escape with amazement, saying, "You fell into the hands of the Old Man of the Sea, and it is a mercy that he did not strangle you as he has everyone else upon whose shoulders he has managed to perch himself." They took me back with them on board their ship. After obtaining many treasures, I came joyfully back to Baghdad, where I did not fail, as before, to give the tenth part to the poor.

It seemed to me that I had reached a garden of delights. There were trees everywhere, laden with flowers and fruit.
Sculptor - Rogelio Evangelista

When I recovered, my enemy was still on my back, and seeing me revive, he prodded me and forced me to get up and stagger about with him under the trees while he gathered and ate the choicest fruits. Sculptor - Nikolay Torkhov

The sails were hoisted, and we thought we had escaped. The rocs soared into the air directly over our vessel.
Sculptor - Etual Ojeda

The Sixth Voyage

After sailing for a while, a violent storm shipwrecked us on a remote island. Sculptor - Bouke Atema

The rocky shore upon which we stood was strewn with the wreckage of a thousand gallant ships. Sculptor - Peter Vogelaar.

After a year of repose, I prepared to make a sixth voyage against the objections of my friends and relations. I traveled a considerable way overland and finally embarked from a distant Indian port with a captain and a ship fit to make a long voyage. After sailing for a while, a violent storm shipwrecked us on a remote island, and we began to lament our sad fate. Mountains formed a seaward boundary, and a narrow strip of rocky shore upon which we stood was strewn with the wreckage of a thousand gallant ships. The bones of the luckless mariners shone white in the sunshine. All around lay vast quantities of priceless merchandise and treasures heaped in every cranny of the rocks.

By the time I had buried the last of my companions, my stock of provisions was so small that I thought I should hardly live long enough to dig my own grave, which I set about doing.
Sculptor - Johannes Hogebrink

 Not far from where we stood, a river of clear fresh water gushed out from the mountain, but instead of flowing into the sea as rivers generally do, it turned off sharply and flowed out of sight under a natural rock archway. When I examined it more closely, I found that the walls were thick with diamonds, rubies, and crystals, and the floor was carpeted with ambergris.

 The captain divided the food equally amongst us, and the length of each man's life depended on the time he could make his portion last. I could live on very little. Nevertheless, by the time I had buried the last of my companions, my stock of provisions was so small that I thought I should hardly live long enough to dig my own grave, which I set about doing. As I did so, an idea struck me. This river which hid underground doubtless emerged again at some distant spot.

The bones of the luckless mariners shone white in the sunshine. All around lay vast quantities of priceless merchandise and treasures heaped in every cranny of the rocks. Sculptors - Greg Jacklin, Ken Abrams, Bruce Phillips, Fred Dobbs

214

This river which hid underground doubtless emerged again at some distant spot. Why should I not build a raft and trust myself to its swiftly flowing waters? Sculptor - Johannes Hogebrink

Why should I not build a raft and trust myself to its swiftly flowing waters? I then made many packages of rubies, emeralds, rock crystals, and ambergris and bound them upon my raft. I launched it, and once out in the current, my raft flew swiftly under the gloomy archway, and I found myself in total darkness.

On I went as it seemed for many nights and days. Though I only ate what was necessary to keep myself alive, the inevitable moment came when I swallowed my last morsel of food. I fell into a deep sleep, and when I again opened my eyes, I was once more in the light of day. A beautiful country lay before me, and my raft, tied to the river bank, was surrounded by friendly-looking black men. "My brother, be not surprised to see us. This is our land, and as we came to get water from the river, we noticed your raft floating down it, and one of us swam out and brought you to the shore. Tell from whence you came and

I then made many packages of rubies, emeralds, rock crystals, and ambergris and bound them upon my raft. I launched it, and once out in the current, my raft flew swiftly under the gloomy archway, and I found myself in total darkness.

where you were going by that dangerous way?" I replied that nothing would please me better than to tell them, but I was starving. They soon supplied me with all I needed.

We marched into the city of Serendib, where the natives presented me to their king. I told my story. They brought my raft in and opened the packages in the king's presence. The king declared that there were no such rubies and emeralds in his entire treasury, as those which lay in great heaps before him. Seeing he looked at them with such interest, I offered them to him. "Nay, Sinbad, Heaven forbid I should covet your riches, I would rather add to them." He then commanded his officers to provide me suitable lodging at his expense. After many days I petitioned the king that I might return to my own country, to which he graciously consented. He loaded me with rich gifts, and I returned to my house in peace.

On I went as it seemed for many nights and days. Though I only ate what was necessary to keep myself alive, the inevitable moment came when I swallowed my last morsel of food. I fell into a deep sleep. Sculptor - Guy Beauregard

The Seventh Voyage

The elephant deposited me upon the side of a great hill, strewn as far as I could see on either hand with bones and tusks of elephants. "This then must be the elephants' burying place." I thought, "They must have brought me here so that I might cease persecuting them."
Sculptors - Paul Hoggard & Remy Hoggard

But the colossal creature, picking me up gently enough, set me upon its back
Sculptor - Radovan Zivny

After my sixth voyage, I was determined I would go to sea no more. I was now of an age to appreciate the quiet life. One day, as fate would have it, I found myself boarding a ship, and for four days, all went well. On the fifth day, we had the misfortune to fall in with pirates, who seized our vessel. They killed all who resisted and made prisoners of those who were prudent enough to submit at once, of whom I was one. They sailed to a distant island and sold us for slaves. I fell into the hands of a wealthy merchant who clothed and fed me well. After some days he sent for me and questioned me about what I could do. I answered that I was a wealthy merchant pirates had captured, so I knew no trade. "Tell me," he said, "can you shoot with a bow?" I replied that this had been one of the pastimes of my youth and that doubtless, with practice, my skill would come back to me. Upon this, he provided me with a bow and arrows and, mounting me with him upon his elephant, took us to a vast forest far from the town. When we had reached the wildest part of it, we stopped, and my master said to me, "This forest swarms with elephants. Hide in this great tree, and shoot at all that pass you. When you have succeeded in killing one, come and tell me." So saying, he gave me a supply of food and returned to the town, and I perched myself high up in the tree and kept watch. Just after sunrise, a large herd of elephants came crashing and trampling by. I let fly several arrows, and at last, one of the great animals fell to the ground dead. I ran back to tell my master of my success. Then we went to the forest together and dug a mighty trench where we buried the elephant I had killed so that when it became a skeleton, my master might return and secure its tusks.

For two months, I hunted thus, and no day passed without my securing an elephant. One morning as I watched the coming of the elephants, I was surprised to see that, instead of passing the tree as they usually did, they paused and surrounded it. They began

Well, my friend, and what do you think now? Have you ever heard of anyone who has suffered more or had more narrow escapes than I have? Is it not that I should now enjoy a life of ease and tranquility?"

trumpeting horribly and shaking the ground with their heavy tread, and when I saw their eyes fixed upon me, I was terrified. The largest of the animals wound his trunk around the stem of my tree and, with one mighty effort, tore it up by the roots, bringing me to the ground entangled in its branches. But the colossal creature, picking me up gently enough, set me upon its back and turned and crashed into the dense forest, followed by the herd. The elephant deposited me upon the side of a great hill, strewn as far as I could see on either hand with bones and tusks of elephants. "This then must be the elephants' burying place." I thought, "They must have brought me here so that I might cease persecuting them." I turned and made for the city as fast as I could go. After a day and a night, I reached my master's house.

The next day we went to Ivory Hill, and he was overjoyed. We loaded our elephant with as many tusks as it could carry, and on our way back to the city, he said, "My brother, since I can no longer treat one as a slave who has enriched me thus, take your liberty. I will no longer conceal from you that these wild elephants have killed several of our slaves. You alone have escaped the wiles of these animals. Now through you, the

whole town will be enriched without further loss of life. Therefore you shall not only receive your liberty, but I will also bestow a fortune upon you." I replied, "Master, I thank you and wish you all prosperity. I also ask liberty to return to my own country." "It is well," he answered, "the monsoon will soon bring the ivory ships hither, then I will send you on your way with riches to pay your passage." At length, we reached Baghdad. Since then, I have rested from my labors and given myself wholly to my family and friends.

Thus Sinbad ended the story of his seventh and last voyage, and turning to Sindbad, the porter, he added, "Well, my friend, and what do you think now? Have you ever heard of anyone who has suffered more or had more narrow escapes than I have? Is it not that I should now enjoy a life of ease and tranquility?" Sindbad drew near and, kissing his hand respectfully, replied, "Sir, you have indeed known fearful perils. My troubles have been nothing compared to yours. Moreover, your generous use of your wealth proves that you deserve it. May you live long and happily in the enjoyment of it." Sinbad then gave him a hundred sequins, and henceforward counted him among his friends.

Sinterklaas

Ted and I underestimated the social aspect of this project. I am grateful that Brian was passionate about that detail, especially in the planning stages. He organized room assignments and meticulously grouped sculptors in suites to create the most compatible living conditions. Ted and I paid no attention to this aspect of planning since the project's creative and technical aspects had us bogged down. Thankfully social life was self-organizing since most of the artists were already colleagues and friends who meet at different sand sculpting events around the world. The hotels had Foosball and ping pong, where the Russians dominated. We had a large chill-out area at the event site where we ate together and played badminton at lunch. Sometimes well past lunch when Lucas would wander through and yell, "Time to work!" Besides the storm banquet, there wasn't many organized social events. It was December, and the project was coming to a close. We needed a Christmas party but didn't know it. The Dutchies saved the day.

"Dutchies" are what the sand community call sand sculptors from the Netherlands. Thanks to Gerry Kirk, the Netherlands is well-represented in the profession. He brought modern sand sculpting from California to Europe in the nineties. As a result, large-scale sand parks flourished there and his organization trained many young Dutch artists to facilitate these endeavors. This is why a good number of Dutch carvers were on our crew.

The Dutch celebrate the winter solstice differently than in Canada and the US. Instead of Santa Clause, their gift bearer is called Sinterklaas. He rides a horse on the house roofs and his helpers, the Piets, go down the chimney to deliver gifts. The

Lucas came out as Klaas and delivered the driest, funniest roasts imaginable.

Poetry was read, tears shed, and laughs were had.

After the last roast was delivered, Johannes announced he had something to say.

celebration has some controversies, but those are not for this tale. The relevant element of this celebration is the family roast tradition, where the roastmaster is Sinterklaas. Through poetry and humor, the roastee intends to take the pointed observations about them as good-spirited, not as criticism or insult. With only found objects and spontaneous creativity, the Dutchies assembled a Sinterklaas roast for our sand family, and it was "gezellig".

We all gathered on Sinterklaas eve with anticipation. Lucas came out as Klaas and delivered the driest, funniest roasts imaginable. Poetry was read, tears shed, and laughs were had. The climax came when Johannes was called up to the lap of Klaas. At first, there was confusion as Klaas asked, "Are you enjoying your time here? Are you making new friends?" It dawned on everyone else before Johannes. The rumors had gone around the crew that he was flirting with another sculptor that was married to another on the job. When Sinterklaas asked, "Are you more friendly with someone in particular?" A hush went over the crowd. It was somewhere between snickering and gasping. We cringed through more of this awkward humor until it was someone else's turn to sit on Klaas's lap. After the last roast was delivered, Johannes announced he had something to say to the crowd. He stood up and stated that they were only friends and that he would never do anything to harm his good friend Nikolay. That awkward moment was the begining of a love story. Ten years after the job ended, they married each other. Nikolay also found new love and married again.

Through poetry and humor, the roastee intends to take the pointed observations about them as good-spirited, not as criticism or insult.

226

Sculptors Enguerrand David and Leonardo Ugolini contemplate their shared sculpture. They slowly reveal this masterpiece out of the formed sand from top to bottom, removing the forms as they go. Everyone on this multi-sculpture pile had to keep pace with each other. Being friends and colleagues for years enables them to play together like a well-honed jazz band.

Aladdin and the Wonderful Lamp

Aladdin was a poor and undisciplined boy raised by only his mother. A wicked sorcerer chose him for a devious plan. He pretended to be the brother of Aladdin's late father Qaseem, and convinced Aladdin he would make him a wealthy merchant. The sorcerer's real motive was to use Aladdin to retrieve a magic lamp that gave tremendous power to whoever possessed it. The Sorcerer knew where to find it, but the lamp was protected by a spell where he could only receive it from the hand of another. He had picked out Aladdin as fool enough for this purpose, intending to get the lamp and kill him afterward.

The Sorcerer brought Aladdin on a journey to find the lamp, and they reached two mountains divided by a narrow valley. "I will show you something wonderful. Gather up sticks while I kindle a fire." The Sorcerer threw magic powder on the fire and chanted strange words. The earth trembled and opened before them, revealing a square flat stone with a brass ring in the middle to lift it. Aladdin tried to run away, but the magician caught him and struck him down. "What have I done, uncle?" He cried. The magician said in a kindly tone, "Fear nothing but obey me. Beneath this stone lies a treasure to be yours, and no one

"These halls lead into a garden of fine fruit trees where the fruits are gems. Walk on till you come to a niche in a terrace where there stands a lamp. Bring it to me." *Sculptors - Nikolay Torkhov & Paulina Siniatkina*

The Sorcerer flew into a rage and through the powder on the fire. The stone rolled back into its place, trapping Aladdin in the pitch-black cave. Sculptor - Nikolay Torkhov

else may touch it, so you must do exactly as I tell you." He lifted the stone, revealing steps going down into the darkness. "Go down," said the magician, "at the foot of those steps, you will find an open door leading into three large halls. These halls lead into a garden of fine fruit trees where the fruits are gems. Walk on till you come to a niche in a terrace where there stands a lamp. Bring it to me. Go through without touching anything but the lamp, or you will die instantly."

He drew a ring from his finger and gave it to Aladdin, bidding him good luck. Aladdin found everything as the Sorcerer had said. He couldn't resist the gems hanging from the trees and disobediently filled his pockets. Having found the lamp, he returned to the mouth of the cave. From the opening, the Sorcerer reached down and cried, "Give me the lamp." Aladdin grew suspicious after the Sorcerer had lied about dying if he touched anything. So, he refused to hand over the lamp

Having found the lamp, he returned to the mouth of the cave. From the opening, the Sorcerer reached down and cried: "Give me the lamp." Aladdin grew suspicious. Sculptor - Nikolay Torkhov

until he was outside the cave. The Sorcerer flew into a rage and threw the powder on the fire. The stone rolled back into its place, trapping Aladdin in the pitch-black cave.

Aladdin rubbed his hands in despair and inadvertently rubbed the magic ring lent to him by the sorcerer as protection. A jinn appeared, and after the initial fright passed, it granted Aladdin's wish to take him and the lamp home to his mother. While Aladdin was away, his mother cleaned the lamp. When she rubbed it, a far more powerful genie appeared. It said it was bound to do their bidding. Aladdin's mother begged Aladdin to sell it and have nothing to do with devils. "No," said Aladdin, "chance has its virtues. We will use it and the ring likewise."

One day Aladdin heard an order from the Sultan proclaiming that everyone was to stay at home and close their shutters while Princess Badroulbadour went to and from the bathhouse. Aladdin was seized by a desire to see her face, which always went veiled. He hid behind a door and peeped through a crack. The princess lifted her veil as she went in and looked so beautiful that Aladdin fell in love with her at first sight. He convinced his mother to take the jewels Aladdin

He hid behind a door and peeped through a crack. The princess lifted her veil as she went in and looked so beautiful that Aladdin fell in love with her at first sight. Sculptor - Pedro Mira

Aladdin rubbed his hands in despair and inadvertently rubbed the magic ring lent to him by the sorcerer as protection. A jinn appeared. Sculptor ~ Ivan Zverev

had taken from the cave to the Sultan. Turning to the vizier, the Sultan was amazed and said, "What sayest thou? Ought I not to bestow the princess on one who values her at such a price?" The Sultan's vizier, who wanted her for his son, begged him to withhold her for three months. The Sultan obliged, and Aladdin waited patiently. Before three months had elapsed, he found out that the son of the grand-vizier was to marry the Sultan's daughter that night. He rubbed the lamp, and the genie appeared, saying, "What is thy will?" Aladdin asks the genie to scare the vizier's son. The genie did this and frightened the vizier's son's wits out, threatening that it would continue to haunt him if he married the princess. Terrified, He told the Sultan he would rather die than marry the princess.

When the three months were over, Aladdin sent his mother to remind the Sultan of his promise. On the vizier's advice, he said, "Your son must first send me forty gold basins full of jewels, carried by eighty guards, splendidly dressed." He summoned the genie, and in a few moments, the eighty guards arrived, and Aladdin sent them to the palace, two by two, followed by his mother. They were so richly dressed, with such splendid jewels in their girdles, that everyone crowded to see them. Upon receiving the parade, the Sultan told Aladdin's mother, "Good woman, return and tell your son that I wait for him with open arms." Aladdin called the genie. "I want a scented bath," he said, "a richly embroidered habit, a horse surpassing the Sultan's, and twenty servants to attend me. Besides this, six beautifully dressed women to wait on my mother, and lastly, ten thousand pieces of gold in ten purses."

Aladdin mounted his horse and passed through the streets, the servants strewing gold as they went. When the Sultan saw him, he came down from his throne, embraced him, and led him into a hall where a feast was spread, intending to marry him to the princess that day. Aladdin refused, saying, "I must build a palace fit for her first," and took his leave. Once home, he told the genie, "Build me a palace of the finest marble, set with jasper, agate, and other precious stones. In the middle, you shall build me a large hall with a dome, its four walls of gold and silver, each side having six windows, whose lattices, all except one, which is to be left unfinished, must be set with diamonds and rubies. There must be stables and horses and grooms and servants!" The genie built the palace that evening, and the king was so impressed Aladdin and Badroulbadour wed the next day.

Over time Aladdin won the hearts of the people with his gentle bearing. He was made captain of the Sultan's armies and won several battles but remained modest and courteous as before. He lived in peace and contentment for several years. But far away in Africa, the Sorcerer remembered Aladdin. Rumors of Aladdin's feats had traveled far and wide, making the magician suspicious that instead of perishing in the cave, he might have escaped and was using the lamp. The sorcerer returned to Aladdin's city and got his hands on the lamp by tricking Aladdin's wife, who was unaware of the lamp's importance. Disguised as a merchant, he offered an exchange, "New lamps for old." Once the Princess gave the Sorcerer the lamp, he rubbed it, and the genie was at his service. He ordered it to take the palace and all its contents to his home in the Maghreb.

The following day the Sultan looked out the window toward Aladdin's palace and rubbed

his eyes. It was gone. He sent for the vizier and asked what had become of the palace. The Vizier looked out and was lost in astonishment. He put it down to enchantment and sent thirty men on horseback to fetch Aladdin in chains. The Sultan ordered his execution. The executioner made Aladdin kneel, bandaged his eyes, and raised his scimitar to strike. At that instant, the vizier saw the crowd scaling the walls to rescue their beloved Aladdin. He called to the executioner to stay his hand. The people looked so threatening that the Sultan gave way and ordered Aladdin to be unbound and pardoned him in the sight of the crowd. "Where are my palace and my daughter?"

Disguised as a merchant, he offered an exchange, "New lamps for old." Once the Princess gave the Sorcerer the lamp.
Sculptor - Etual Ojeda

He told the genie, "Build me a palace of the finest marble, set with jasper, agate, and other precious stones. In the middle, you shall build me a large hall with a dome, its four walls of gold and silver, each side having six windows, whose lattices, all except one, which is to be left unfinished, must be set with diamonds and rubies. There must be stables and horses and grooms and servants!" Sculptors - Enguerrand David & Leonardo Ugolini

Aladdin rubbed the magic ring he still wore. The genie he had summoned in the cave appeared and asked his will." Bring my palace back." "That is not in my power," said the genie, "I am only the jinn of the ring; you must ask the jinn of the lamp."

Demanded the Sultan. Aladdin begged for forty days to find her, promising he would return and suffer death at the Sultan's pleasure if he failed.

Aladdin rubbed the magic ring he still wore. The genie he had summoned in the cave appeared and asked his will. "Bring my palace back." "That is not in my power," said the genie, "I am only the jinn of the ring. You must ask the jinn of the lamp." "But you can take me to the palace and sit me under my wife's window." He at once found himself in Africa, under the princess's window. There was great joy at seeing each other again. "Tell me what has become of an old lamp I left on the cornice in the hall?" She told him about the Sorcerer's trick. "He carries the lamp with him," said the princess, "I know, for he pulled it out

of his breast pocket to show me." They hatched a plan that the princess would pretend to be willing to marry the Sorcerer, and they would poison the magician's drink during the celebration. Their plan worked, and Aladdin took back the lamp from the dead Sorcerer. He bid the genie to take the palace, and all in it, back to Aladdin's home. The Sultan, mourning for his daughter, looked up and rubbed his eyes, for the palace stood as before! Aladdin received him in the palace, with the princess at his side. Aladdin told him what had happened and showed him the dead body of the Sorcerer, so he might believe it was the Sorcerer at fault. It seemed Aladdin would live the rest of his life peacefully, but it was not to be.

They hatched a plan that the princess would pretend to be willing to marry the Sorcerer, and they would poison the magician's drink during the celebration.
Sculptor - Sue McGrew

The African magician had a brother who was more wicked and more cunning. He vowed to avenge his brother's death. He disguised himself as a holy woman called Fatima (who he murdered to take her identity) and went to the palace of Aladdin. All the people thought he was the holy woman and gathered around him, kissing his hands and begging for his blessing. The princess long desired to see Fatima, so she sent for her. The false Fatima had entered the inner circle of Aladdin's palace and began hatching his plans of betrayal. The lamp's genie warned Aladdin of the infiltrator posing as the holy woman and that he had protection against the genie's power and meant to kill Aladdin. Aladdin returned to the princess and asked her to fetch the holy Fatima saying his head ached. When the magician came disguised as Fatima, Aladdin seized his dagger and pierced the imposter's heart. "What have you done?" Cried the princess. "You have killed the holy woman!" "Not so," replied Aladdin, "but a wicked magician," and told her about the deception. After this, Aladdin and his wife lived in peace. He succeeded the Sultan when he died and reigned for many years, leaving a long line of kings behind him.

Aladdin and his wife lived in peace. He succeeded the Sultan when he died and reigned for many years, leaving a long line of kings behind him. Sculptor - Arianne van Rosmalen

End

The Artists

Adam Dunmore	Agnese Rudzite Kirillova	Aleksandr Skarednov	Alexsey Samolov	Anatolijs Kirillovs
Andrey Vazhynskyy	Andrius Petkus	Anika Koenigsdorff	Arianne van Rosmalen	Barry Swires
Benjamin Probanza	Bob ATISSO	Bouke Atema	Brent Terry	Brian Turnbough
Bruce Phillips	Calixto Molina	Charlotte Kolff	Damon Langlois	Daniel Doyle
Dave Wielders	Delayne Corbett	Denis Bespalov	Denis Kleine	Dennis Storlie

Dmitry Klimenko	Egor Ustyuzhanin	Enguerrand David	Etual Ojeda	Fergus Mulvany
Fred Dobbs	Greg J Grady	Greg Jacklin	Guy Beauregard	Guy-Olivier Deveau
Igor Akimov	Ilya Filimontsev	Ivan Zverev	Jeroen Advocaat	Jihoon Choi
Johannes Hogebrink	JOOheng Tan	Joris Kivits	Katsuhiko Chaen	Ken Abrams
Ken Barnett	Kirk Rademaker	Leonardo Ugolini	Lucas Bruggemann	Lucinda Wierenga

Martin De Zoete	Max Bespalov	Maxim Gazendam	Melineige Beauregard	Nicola Wood
Nikolay Torkhov	Paulina Siniatkina	Pedro Mira	Peter Vogelaar	Phil Olson
Rachel Stubbs	Radovan Zivny	Remy & Paul Hoggard	Rogelio Evangelista	Shay Dobbs
Sue McGrew	Susanne Ruseler	Sybren Huizinga	Tae-in Kim	Ted Siebert
Uldis Zarins	Wael Alomani	Wilfred & Edith Stijger	Yosef Bakir	Yousef Aldaour

The Design

Although I sculpt sand professionally, I have another career as an Industrial Designer. I am an architect of objects. Like an architect designs buildings and spaces, I design the manufactured objects you use for work or play. It is related to sand sculpture because it is creative, sculptural, and it integrates art and engineering. Industrial Design differs in a few aspects. In my design work, I make nothing with my own hands. I help others manifest their thoughts and ideas into physical form. Visualization by drawings, plans, models, instructions, and words are my tools.

As a sand sculptor it's a more spontaneous and hands on process. I plan a bit, but let the sand guide me. It is about the act of doing since the result is temporary, sometimes only lasting a few days. In my design work, the process is usually never seen, and the result is mass-produced. This project was a marriage of these two lines of work combining my skills as a designer with my sand sculpting experience to provide the creative direction for what I consider as my life's work. These are highlights from my concept art and engineering plans for the project.

Aladdin - the wonderful lamp

Aladdin joined his hands and he rubbed the ring which the magician had put on his finger, and of which he knew not yet the virtue. Immediately a genie of enormous size and frightful aspect rose out of the earth, his head reaching the roof of the vault, and said to him: "What wouldst thou have? I am ready to obey thee as the slave of all who may possess the ring on thy finger; I, and the other slaves of that ring."

250

The palace concept sketch. This towering castle would be over fifty two feet high. We would build a tunnel with a shipping container covered with sand so visitors could walk through the palace at ground level. Many stories had palaces in them so this central element was used as a backdrop to many sculptures. If you look back you can notice this in many photos.

21·06·13

253

The following are highlights of the concept sketches I created to visualize the tales and the sculpture park. Each sculpture would be a snapshot from the chosen stories from The Arabian Nights. To respect Islamic custom, the style of all living elements was abstracted slightly to not be too life like. This created a unique style to the overall design.

257

258

260

Communication went back and forth with Ted and Yousef to produce more than seventy layout sketches. They slowly became more and more refined and intricate. We developed a walk over palace, a maze, a theater, gallery, chill zones, all in an immersive sand sculpture park that would come alive at night with lights, food venues and street performers. It was an extremely ambitious project.

Sand Sculpture Park Map

Sunset Direction

- Big 5 Storage
- Big 5 office
- Security lookout tower
- Sculptors mess hall, entertainment area, mini grocery store 15m × 55m
- Storage lockers
- Bathrooms
- Sand Cafe
- Seating
- cafe Host
- Food entertainment info
- Exit
- Seating
- Maze with "easter egg" sculptures. Walls are formed only.
- Kids Sand box
- Indoor treasure
- Seating
- Bathrooms
- Shops
- VIP Square
- Exit
- Steel containers for walking over and through/under sculpture
- Walk over palace (Sheherazade story)
- Gift Shop Making of Gallery
- Indoor sculpture zone
- VIP Lounge reception area
- Temple Flame Show
- Food
- Bathrooms
- Bathrooms
- Forced perspective view
- Exit
- Exit
- Shops
- Shops
- Shops
- Ticketing
- Ticketing
- Shops
- Enter
- Projected image on wall (Kuwait Flag?)

262

| 31 | The Roc Sandbox
| 32 | Sinbad The First Voyage
| 33 | The Second Voyage
| 34 | The Third Voyage
| 35 | The Fourth Voyage
| 36 | The Fifth Voyage
| 37 | The Sixth Voyage - Maze
| 38 | The Seventh Voyage
| 39 | Gift Shop
| 40 | VIP Lounge

| 21 | Codadad and His Brothers
| 22 | the Prince and the Ogress
| 23 | Scheherazade
| 24 | The three princes and the princess nouronnihar
| 25 | Kamar Al-Zaman and Budur
| 26 | The king of Persia and the princess of the sea
| 27 | The Fisherman and the Genie
| 28 | The Tale of the Ensorcelled Prince
| 29 | Ali Baba and the Forty Thieves
| 30 | Aladdin and the wonderful lamp

| 7 | Prince Ahmed and the Fairy Banou
| 8 | The Queen of the Serpents
| 9 | The Third Calendar, Son of a King
| 10 | The Shipwrecked Woman and Her Child
| 11 | The Sisters Who were Changed to Dogs

12 The City of Brass
13 The Three Apples
14 The Angel of Death and the Rich King
15 The Man Who Stole the Dish of Gold
16 The Little Hunchback
17 Sculptors Showcase
18 The Enchanted Horse
19 The Talking Bird
20 Abdullah the Fisherman
 and Abdullah the Merman

1 Entrance
2 The Cock and the Fox
3 The Fishes and the Crab
4 The Wolf and the Fox
5 The Ox and the Mule
6 The Birds the Beasts

The overall park was my sculpture. Each poundup was planned and shaped to minimize carving and establish the basic form of the sculptures. This enabled the poundups to be built quickly and the sculpting to go faster. A color coded system identified form size so a minimal amount of documents could be used to construct the poundups. Shown is the Aladdin poundup plan.

NUMBER	SIZE (Ft)	
4	1	FLEX FORM
13	1.5	
23	2	
4	2.5	
19	3	
71	4	
81	5	
80	6	
63	7	
191	8	

The palace construction overview. The base was constructed without forms. This is known as a "pad". The requirement was for visitors to be able to walk over and stand on top of the towering structure.

STAGE-1
SOFT PACK PILE AND RAMPS

STAGE-2
TOP FORMS

STAGE-3
REMOVE EXCESS SOFT PILE & RAMPS

STAGE-4
FINISHED PALACE PILE WITH ALL FORMS & STAIRS.

The sand walls were a feat in themselves. The image bellow is a sample of the design drawings.

266

Bibliography

1. **Burton, Sir Richard Francis.** The Book of the Thousand Nights and a Night. 1900.

2. **Dixon, E. & Batten, J. D.** Fairy tales from the Arabian Nights. 1893

3. **Housman, Laurence.** Stories from the Arabian Nights. Hodder and Stoughton, 1907.

4. **Payne, John.** The Book of the Thousand Nights and One Night, Volume I, 1901.

5. **Wiggin, Kate Douglas & Smith, Nora Archibald.** The Arabian Nights. 1909.

6. **Lang, Andrew & Ford, Henry Justice.** The Arabian Nights Entertainments. Courier Corporation, 1929.

7. **Dawood, N. J. & Harvey, William.** Tales from the Thousand and One Nights. Penguin Group, 1979.

8. **Dulcken, Henry William.** Dalziel's Illustrated Arabian Nights' Entertainments. 1865.

Trust is the glue of friendship. Without trust, each one of us is on his own. Sculptor - Brian Turnbough

Producers

A special thank you to the following producers of this book.

Dennis Storlie

Anthony Agnello

and

Charlie Beaulieu
The 5th member of "The Big 5"

After one thousand and one nights, he did not care that she had no more stories to tell. All he knew was that watching her die would be a pain he could not stand. Sculptor - Denis Kleine

"Selfie In Sand" Damon Langlois - Photograph- Martha Lardent

About the author

Damon Langlois, designer, sculptor, father, and author, has been sculpting sand professionally and competitively for thirty years. He is the recipient of many awards, including four Team World Championship of Sand Sculpting and a Solo World Championship title. Damon designed and engineered the Guinness World Record Tallest Sandcastle at forty-six feet tall with Ted Siebert in 2015. He created the viral Internet sand sculpture "Liberty Crumbling" which won first place at Texas Sandfest in 2019. As the founder of Codetta Product Design, Damon is also an inventor and industrial designer with 14 patents and multiple design awards. He lives with his family in a forest in a house he designed and built on the west coast of Canada. He usually doesn't brag like this but he needs to make an impression for this bio.

www.storiesinsand.com